A–Z
OF
LANCASTER

PLACES - PEOPLE - HISTORY

Billy F. K. Howorth

AMBERLEY

I would like to dedicate A–Z of Lancaster to my Mum Lesley,
for all her love, support and encouragement throughout my life.

First published 2016

Amberley Publishing
The Hill, Stroud, Gloucestershire, GL5 4EP
www.amberley-books.com

Copyright © Billy F. K. Howorth, 2016

The right of Billy F. K. Howorth to be identified
as the Author of this work has been asserted in
accordance with the Copyrights, Designs and
Patents Act 1988.

ISBN 978 1 4456 6340 1 (print)
ISBN 978 1 4456 6341 8 (ebook)

British Library Cataloguing in Publication Data.
A catalogue record for this book is available
from the British Library.

Origination by Amberley Publishing.
Printed in Great Britain.

Contents

Introduction

This book is not a complete A–Z of Lancaster, but it aims to tell the story of some of the most important buildings, residents, events and lesser-known heritage from Lancaster's history. The stories and history told in this book are chosen first from my own interests, but also because some of Lancaster's history has been lost to time, and I feel that it should be retold.

In my own view, Lancaster has such an interesting history set over the period of two millennia and takes in some of the most important events ever seen in British history. As you will discover, Lancaster has played a key part in British history, whether it was holding the Pendle Witch Trials, playing its part in the slave trade or giving dinosaurs to the world. I hope that you, as the reader, will find the subjects discussed in this book interesting and informative, and hopefully, I may encourage you to read further into some of the subjects covered and possibly discuss them among family and friends.

This book would not have been made possible without the works of many different authors over the past century who have taken it upon themselves to research and write about Lancaster's history. They have been a source not only of information but also of encouragement while writing this book. Where possible, this book has been researched using contemporary sources, and I have, where appropriate, tried to illustrate each chapter with my own photographs, as well as using some original documents, including maps and photographs. It is well worth visiting the collections that house the originals.

I would also like to thank Abbott Hall Art Gallery, Dot Boughton, Humphrey Bolton, Lancashire Museums, Lancaster City Museum, Lancaster Maritime Museum, Leighton Hall, The Inn at Whitewell, The King's Own Royal Regiment Museum, The Landmark Trust and Windsor House Antiques for their assistance while writing my book.

Map of Lancaster

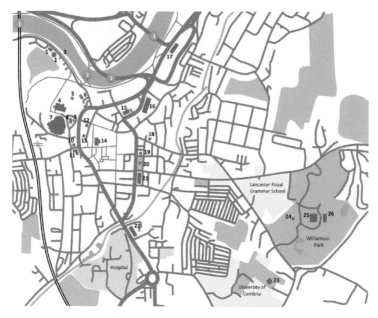

Map of Lancaster showing notable sites. (Author's own illustration)

Key to the Map

Bridges (Red Circles)
1. Carlisle Bridge
2. Lune Millennium Bridge
3. Greyhound Bridge
4. Skerton Bridge

Notable Sites and Buildings (Black Numbers)
1. Wagon and Horses Pub
2. Old Customs House
3. St George's Quay
4. Lancaster Priory
5. Roman Bathhouse
6. The Three Mariners Pub
7. Lancaster Castle
8. The Judge's Lodgings
9. The Covell Cross
10. The Merchants Inn
11. The (Royal) Kings Arms Hotel
12. The Sun Inn
13. The Music Room
14. Old Town Hall
15. St John's Church
16. Gillows Buildings
17. Bridge Houses
18. The Golden Lion Inn
19. No. 2, Dalton Square
20. The Victoria Memorial
21. New Town Hall
22. Springfield Barracks
23. Bowerham Barracks
24. Greg Observatory
25. Ashton Memorial
26. The Palm (Butterfly) House

Ashton Memorial

One of the most prominent buildings on the Lancaster skyline is the imposing structure of Ashton Memorial, one of the largest follies in the country. When we look at Ashton Memorial and Williamson Park, we can see a connection between a wealthy family and a city that they loved.

The Williamson family had been making their mark in Lancaster since the mid-nineteenth century. The first major project undertaken was by James Williamson senior, who began the creation of Williamson Park in the 1870s. The plan was to include elaborate landscapes and gardens laid out by John Maclean, featuring a large ornamental lake and an artificial waterfall. It was a formidable undertaking and provided relief work for laid-off workers during the cotton famine caused by the American Civil War. Sadly, Williamson senior did not live to see his work completed, and the project was completed by his son Lord Ashton.

James Williamson junior was born on 31 December 1842 and was the third of four children of James Williamson senior, a Lancaster businessman who ran a linoleum and oil cloth company. He studied, like many affluent people of the time, at Lancaster Royal Grammar School and eventually began working in the family business. From a very early age, he was extremely driven, eventually taking over the management of

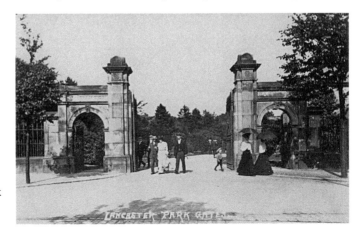

Gates of Williamson Park from an old postcard. (Author's collection)

the company in 1875. During this period, he set about expanding the company and succeeded in making himself into a multimillionaire and earned the title of the 'Lino King.' The company had such a reputation that they sold their goods around the world from North America and Europe to further afield.

Throughout all of his success and the profits he made, he never forgot the town where he had grown up and worked; he became the town's biggest employer and arguably its biggest philanthropist. As a reward, he received various honours, becoming High Sheriff of Lancaster in 1885. He served as Liberal MP from 1886 to 1895 and in 1895 was given a peerage, taking the title Baron Ashton. He donated the park to Lancaster Corporation in 1881, and it was formally opened for public use in 1896.

At the beginning of the twentieth century, the park was improved, and Sir John Belcher was commissioned to design a temple, a fountain, and a palm house. He was also commissioned to construct a monumental building a few years later, in 1907. It stands around 35 m tall and is built out of mix of stone with a copper dome; it was originally intended to be a memorial for his deceased second wife, but by the time of completion in 1909, he was remarried for a third time to Florence Maud Whalley. The Ashton Memorial cost £87,000 to build, a fabulous sum in those days. The contractors were Waring and Gillow of Lancaster, better-known in their role of cabinet makers. However, from the very start of construction, there were many issues that the builders and designers had to overcome. It was originally going to be built completely out of solid stone, however, due to the increase in costs, the builders began to experiment using new methods and cheaper materials, including the use of concrete clad with stone, brick to support load-bearing elements and steel girders. Unfortunately, these changes would plague the monument for several decades. It was officially opened on 24 October 1909 as the centrepiece of Williamson Park.

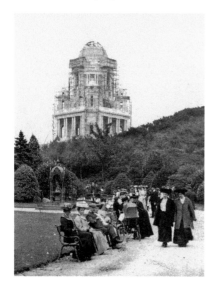

Construction of Ashton Memorial from an old postcard. (Author's collection)

Interestingly, the memorial is also close to the mathematical centre of the United Kingdom of Great Britain and Northern Ireland.

Within a decade of completion, the memorial was beginning to suffer significant damage and was in urgent need of repair. Rainwater had begun to seep into the structure and was affecting the concrete, causing it to crack; this led to the steel within the building beginning to rust. By the 1920s, although Lord Ashton had moved away from Lancaster to Lytham St Annes, he provided additional funding so that the repairs could be undertaken. He eventually passed away in 1930, but after his death, his wife continued to fund renovations.

In 1942, the Palm House suffered damaged from a fire, and its interior was destroyed. Twenty years later, there was another serious fire, this time within the memorial, damaging the structure and dome, and by 1981, it had become structurally unsafe and was closed. A few years later, an appeal was started to raise the estimated £600,000 to restore Ashton Memorial to its former glory, and between 1985 and 1987, renovations were undertaken on both the Palm House and the memorial that finally reopened in May 1987. Further renovations, this time to the grounds, were started in 1999, when the lake, fountain and waterfall were refurbished. Even now, over 100 years later, the Ashton Memorial stands proudly on the landscape and has become the most famous building in the town.

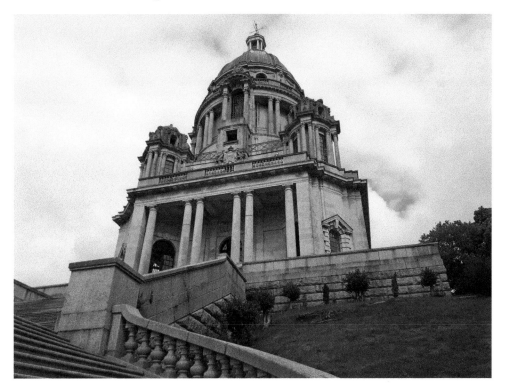

Ashton Memorial. (Author's photograph)

Bathhouse

In Lancaster, to many people's surprise, there is one important Roman site that tends to be overlooked and rarely visited. If you walk down the path behind the priory, you will come across a couple of sloping fields known as Vicarage Fields, and by taking a small path into the one located directly behind the priory, you will come upon the remains of Lancaster's Roman bathhouse.

The story of Romans in the northwest began around AD 71, and within a couple of years, they had complete control of the north. The foundation of Lancaster's Roman fort was probably at the request of Quintus Petillius Cerialis who was the Roman governor of the province between AD 71 and AD 74. The location of the site was very important as it had a clear vantage point of the area with the river, sea and surrounding land all visible from the fort. We know details of the two units that were based in Lancaster during the first and second centuries; they were the Ala Gallorum Sebosiana and the Ala Augusta, both of these were cavalry (ala) units. It is believed that a cavalry unit numbered around 500–1,000 soldiers, split into 16–24 units and around 500 horses.

The first fortress to be constructed on the site used timber and turf in its construction, but we know that in AD 102, a new fort was built, this time using stone. Around the same time, a small village developed around the fort that would have housed the families of those garrisoned at the fort, as well as small businesses, industries and a market. The layout of the first Roman town in Lancaster can clearly be seen over a

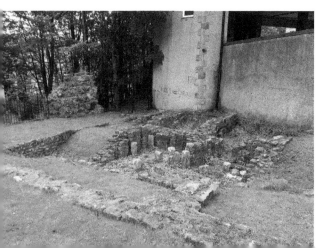

The remains of the Bathhouse.
(Author's photograph)

millennium later when we examine maps from the medieval period with many of the roads and streets still in place.

Within forty years of the second fort being constructed, the garrison had to move further north to assist with the expansion of the Roman Empire in Scotland. Around AD 250, the garrison once again returned to Lancaster, and a third fort was built. In addition to the new fort, the bathhouse was also constructed just outside of the fort's northern extent. Bathhouses were a very popular Roman tradition and were a place not only for cleansing but also for meetings and socialising. Lancaster's bathhouse is believed to have been part of a Roman hotel that was used to accommodate visiting dignitaries and people of a higher social standing, equipped with all the latest Roman features and luxuries.

From the remains of the bathhouse, we can still clearly see the layout of two rooms, the *caldarium* (a sauna-like room with hot plunge pool) and the *tepidarium* (a warm room used for relaxing between rooms). Various excavations at the site over the decades have uncovered the other rooms in various states of preservation as well as a host of artefacts, including pieces of painted plaster that would have originally adorned the bathhouse walls.

The fort was once again rebuilt for the final time around AD 330. During this period, the Roman Empire in Britain was stable with little unrest; the new threat was by raiders sailing from Ireland. In order to address this concern, the orientation of the fort was changed to face the river. The fort remained in use until the early fifth century, after which the Roman Empire began to decline, eventually falling around AD 476. After this period, the fort was abandoned and left to fall into ruin. The only remaining part of the last fort that exists is a small fragment of stone wall, known as the Wery Wall, located very close to the remains of the bathhouse. Another important reminder of this period comes from the tombstone of a Roman cavalryman that was discovered in 2005. The memorial was for a man called Insus who came from Germany. It has now been carefully restored and is located in Lancaster City Museum.

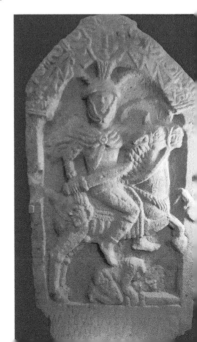

Roman Cavalryman Tombstone in Lancaster City Museum.
(Author's photograph)

Lancaster Castle

One of the most prominent and important structures of the Lancaster skyline is the imposing fortress that is Lancaster Castle. Standing proudly on Castle Hill for over 900 years, it has been the site of many important events not just in local history but also within British history and is the oldest structure standing in Lancaster.

After the fifth century, with the fall of the Western Roman Empire, the history of the Roman fort and the town was lost. It took until the eleventh century and the arrival of the Normans during their conquest of Britain before we once again find evidence for the importance of Lancaster. Lancaster had become part of the Earldom of Northumbria that was claimed by both English and Scottish kings. It is believed that the castle was founded around 1090 on the same site as where the Roman fort once stood. During this period, Roger de Poitou was given the Honour of Lancaster and set about developing the town, building the castle and later the priory. He was part of an unsuccessful uprising against Henry I and in 1102 fled England and in the process had his lands confiscated. Henry I gave the title to his nephew, Stephen of Blois, the future king.

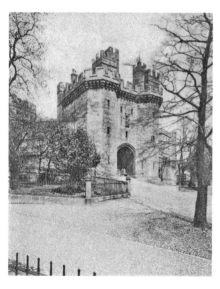

Lancaster Castle Gateway, 1904, from an old postcard. (Author's collection)

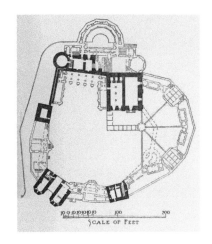

Plan of Lancaster Castle. (Farrer, W. and Brownbill, J. A *History of the County of Lancaster: Vol 8*. London: Victoria County History, 1914)

Once again in 1139, the country was in the midst of a war for the English throne – this time between the Empress Matilda and Stephen. Stephen was able to gain control of the northern frontier by working with David I of Scotland to whom he gave the Honour of Lancaster in 1141. The war ended in 1153 and an agreement was made; it was decided that upon the death of Stephen, his throne would be taken by Henry Plantagenet, the son of Matilda and future Henry II. In addition to this, the title would be returned and given to Stephen's son, William. William died in 1164, and the Honour of Lancaster came back into the possession of Henry II.

Upon the death of Henry II in 1189, the Honour went to his son Richard the Lionheart. Richard was hoping to gain the loyalty of his brother Prince John and gave him the title as an incentive. It is from around this period that we gain the first evidence of the castle being used not only as a fortification but also as a place of incarceration with the earliest records dating to 1196.

During the twelfth and early thirteenth centuries, a huge rebuilding of castles took place across the country as many of those built by the Normans were of timber construction. These were rebuilt using stone, and Lancaster Castle was one of these that was rebuilt. This process was incredibly expensive, as well as labour intensive and time consuming. From the preserved records, we know that in Lancaster, John spent around £630, creating a ditch outside the south and west walls of the castle. We also know that Henry III undertook other constructions, spending £200 in 1243 and £250 in 1254 for work on the gatehouse and construction of a curtain wall.

From the surviving records, we know that over the next hundred or so years, there is very little information regarding construction at the castle. It is believed that the Well Tower dates from the early fourteenth century, and it may have been that during this period the only works undertaken were restoration or maintenance. We do know, however, that in 1322 and 1389, the Scots invaded the area and were able to reach Lancaster Castle, which they damaged. Upon the ascent of King Henry IV in 1399, he set about constructing an impressive gatehouse, and records from this period show us that between 1402 and 1422, over £2,500 was spent on construction at the

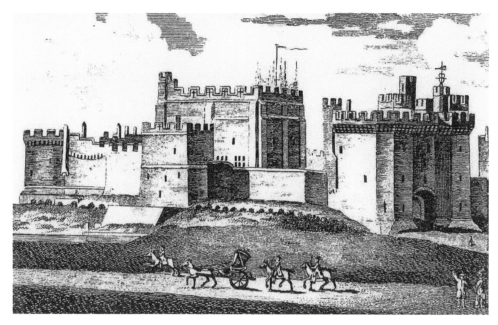

Sketch of Lancaster Castle by Stephen Mackreth, 1779. (Author's collection)

castle. The Scottish invasion marked the last time that the castle would see military activity until the Civil War (1642–1651). The main undertaking at the castle tended to be conservation with a survey made in 1578 leading to the keep being repaired for the sum of £235. A few years later, during the Anglo-Spanish War (1585–1604), it was decided to strengthen the castle in case of invasion.

The most important event that the castle saw during the seventeenth century was the Pendle Witch Trials of 1612 with all the accused being locked away in the castle before standing trial. It was the during the Civil War that the castle would once again see military action and be relied upon for defence. Importantly, at the beginning of the war, Lancaster was poorly garrisoned with only a small number of soldiers and due to this the castle was captured in February 1643 by Parliamentarian forces, who created a garrison at the castle and started to build earthen defences. The Royalists sent an army to try to retake the town with the town's outer defences collapsing in March that year, but the attempted siege failed as additional Parliamentarian soldiers were travelling from Preston to the castle.

Additional attempts to retake the castle in April and June also failed, and the castle was retained by the Parliamentarians until the end of the war in 1651. After the execution of King Charles I in January 1649, parliament ordered the destruction of the castle apart from the buildings used for administration and the jail. Upon the restoration of the monarchy in 1660, King Charles II visited on 12 August and ordered that all the prisoners being held within the jail should be released. At the same time, the High Sheriff of Lancashire and the Justices of the Peace gave a petition to Charles, asking him to assist in repairing the castle. A survey of the castle was done and the

An interior view of Lancaster Castle by J. Weetman, 1824. (Courtesy of Lancashire Museums)

repairs were estimated at £1,957. The same year, George Fox, the founder of the Religious Society of Friends, or Quakers, was imprisoned for his religious teachings.

By the eighteenth century, the castle was once again in a state of decline and in need of renovations. In 1776, John Howard, a prominent prison reformer, visited the castle and recorded the conditions he saw within the prison. His new ideas revolved around separating prisoners by gender and category of their crime that he tried to promote at jails around the country. He also noted the importance of good sanitation as 'gaol fever', now known as typhus, was rife in prisons, killing more prisoners each year than by hanging. The late eighteenth and early nineteenth centuries saw a huge period of building and renovations at the castle that were the last significant development at the castle and were overseen by architect Thomas Harrison, whose work is discussed in a later chapter.

The prison at the castle was closed in 1916 due to a low number of prisoners, but it was used to hold German POWs during the First World War. It was also used as a training area for the police from 1931 to 1937 before once again becoming a functional prison in 1955, when it reopened as a Category C prison for men, finally closing its doors as a prison for good in March 2011. The castle continues to be home to the Crown Court.

Duchy of Lancaster

When we look back at the history of Lancaster, there has always been a close link to monarchy. For hundreds of years, Lancaster has held a unique position with serving monarchs due to them assuming the title of Duke of Lancaster. The Duchy of Lancaster is one of only two royal duchies, and the current Duke of Lancaster is Queen Elizabeth II.

To understand how this came about, we have to travel all the way back to 6 March 1351. It was on this day that the great grandson of Henry III, Henry of Grosmont, the

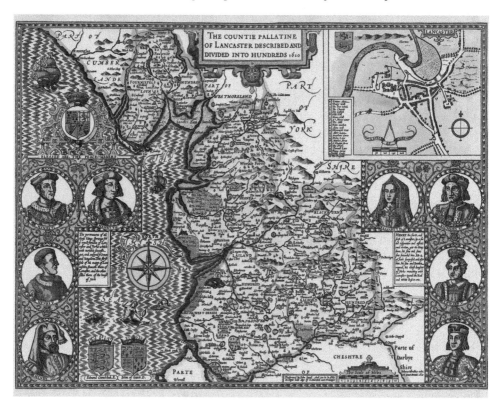

Map of the County Palatine of Lancaster by John Speed, 1610. (Author's collection)

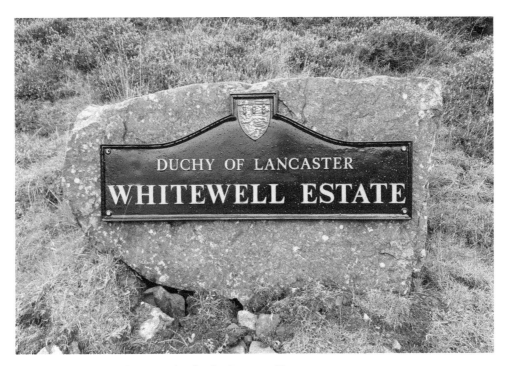

Whitewell Estate marker sign. (Author's photograph)

4th Earl of Lancaster, was given the Dukedom of Lancaster. Unfortunately, his title ceased upon his death on 23 March 1361. A year later on 13 November 1362, the title was once again created, this time for John of Gaunt, 1st Earl of Richmond. John had married Blanche of Lancaster, 6th Countess of Lancaster who was the daughter of Henry of Grosmont and his heiress.

On 4 February 1399, John of Gaunt died and passed the Dukedom to his son, Henry of Bolingbroke, 1st Duke of Hereford. Later that same year, he assumed the throne of England from Richard II, ascending the throne as Henry IV at which point the Dukedom merged with the crown. The third creation was on 10 November 1399 for Henry of Monmouth, the eldest son of Henry IV. In 1413, the 1st Duke ascended the throne as King Henry V, and the Dukedom merged in the crown again.

It is important to know that the Duchy of Lancaster even today exists separately to the Crown Estate as a personal possession and source of revenue for the current monarch and held in trust for future sovereigns. The estate is made up of many assets, including land and properties. Currently, the duchy consists of around 18,433 ha (45,550 acres) of land holdings, urban developments, historic buildings and some commercial properties. The holdings include the Lancashire foreshore from Barrow in Furness in the north to the midpoint of the River Mersey in the south, mineral rights and Lancaster Castle. The Lancashire Survey comprises five rural estates. These are the Winmarleigh Estate and Patten Arms Pub, the Myerscough Estate that has been an important land holding by the Duchy of Lancaster since 1267,

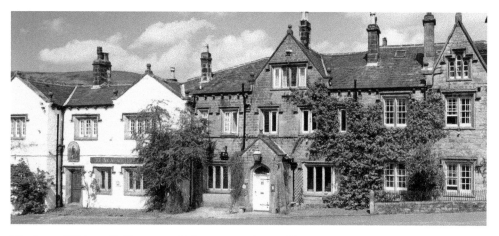

The Inn at Whitewell. (Courtesy of The Inn at Whitewell)

the Salwick Estate between Kirkham and Preston, the Wyreside Estate and the Whitewell Estate.

The Whitewell Estate is the largest duchy estate within the Lancaster area and has a history spanning over 600 years. The hamlet of Whitewell is located in the Bowland Forest within the Ribble Valley and has been the centre of activity within the area since the fourteenth century. The Inn at Whitewell located in Lower Whitewell originally housed the forest courts of the Forest of Bowland and provided accommodation for the Master Forester with the earliest evidence of Master Foresters dating to the twelfth century.

Evidence suggests that the ancient administrative centre of the forest was at Hall Hill, northeast of Whitewell. It is believed that at this site stood an early medieval hunting enclosure known as Radholme, records of which can be found in the *Domesday Book*. From the records, we also know that during the time of John of Gaunt, Sir Walter Urswyk was the Master Forester and evidence suggests that he was responsible for moving the administration centre to Lower Whitewell between 1372 and 1403. From 1600, the role of the Master Forester fell into decline. The forest courts at Whitewell were instead controlled by the Chief Steward who was responsible for appointing a Bowbearer on behalf of the Lord of Bowland. Their responsibility was to protect the local deer as well as enforcing local forest laws.

In the modern day, the Duchy exerts some powers and is responsible for ceremonial duties of the Crown in the historic county of Lancashire that includes parts of the Furness area of Cumbria, Manchester and Merseyside. The Queen appoints the High Sheriffs and Lords Lieutenant in Greater Manchester, Merseyside and Lancashire. The Duchy is administered for the reigning monarch by the Chancellor of the Duchy of Lancaster.

Executions

Lancaster has always had an important connection with crime and punishment, mainly due to the importance of Lancaster Castle and the Assize courts. Up until 1835, it was the only place within Lancashire where these courts took place. Throughout the long history of Lancaster, the town has seen its fair share of hangings, and several buildings within the town have connections to this.

Originally, after sentencing, the condemned would be led out of the castle, and through the town, they would travel up Moor Lane and stop at the Golden Lion inn to have their final drink with their friends and relatives. Afterward, they would continue up towards Gallows Hill, which was located on the moor outside Lancaster, roughly where Williamson Park is now.

During the heyday of the Lancaster Assize, it developed a somewhat gruesome reputation and was often referred to as the hanging court, as it condemned more

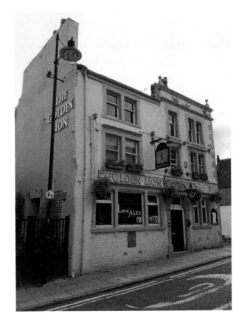

The Golden Lion Inn. (Author's photograph)

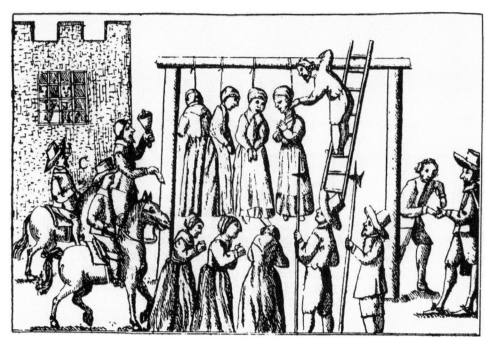

Public Hanging of Witches. (Mackenzie, G. *The Laws and Customs of Scotland in Matters Criminal.* Edinburgh, 1678)

people to death than any other court outside of London, in part due to there being over 200 offences for which the sentence was death. The county of Lancashire employed its own hangmen who also were inmates, which was common around the country during the eighteenth and nineteenth centuries. From the remaining records, we do not have much information regarding these employees, with the exception of Edward Barlow. Barlow was imprisoned for horse theft, which was a capital crime; however, at the time it was difficult to recruit new hangmen. Instead, his sentence was commuted to ten years of imprisonment, provided he continued his work as a hangman. It has been estimated that between 1782 until his death on 9 December 1812, he carried out seventy-one hangings.

After 1800, all hangings ceased to take place on Gallows Hill, and instead public executions took place at what is known as the Hanging Corner towards the rear of the castle. On the east side of the building, you can find a small round tower housing to what is known as the 'drop room'. Upon leaving their cells, the prisoners would be led into this room to say their final prayers and more gruesomely walk past their own empty coffins. They would pass through a small French window-style door and straight onto the balcony-style gallows that had been erected the day before.

These simple gallows consisted of two vertical uprights supporting a crossbeam, a platform was erected around the structure and had trapdoors cut into it, on top of which would stand the condemned. From the surviving records, we know that spectators were allowed within a few feet of the gallows, while many hundreds more

The Hanging Corner. (Author's photograph)

stood on the opposite embankment to watch the events of the day. It was such an important occasion that people would regularly travel from around the northwest to attend these public hangings, often numbering 5,000–6,000 spectators, and in keeping with prior traditions in Lancaster, Saturday was the usual day for hangings as it ensured the largest audience. Those found guilty and put to death would be hanged by the short-drop method, which ensured that there was no struggle in their final moments. Their dead bodies would then be left hanging for an hour after which they would be removed and taken back inside and put into their coffins. The first hanging at the castle occurred on 19 April 1800, when six men, three accused of robbery and three for passing fake bank notes, were executed. A year later, Lancaster saw the largest mass hanging on 12 September, when eight men were put to death.

The last public execution took place in Lancaster on 25 March 1865 and was that of Stephen Burke, who was found guilty of murdering his wife. A few years later in 1868, the government passed a law that required all executions to be conducted in private, ending the public spectacle of hanging. In Lancaster, after this period, hangings took place within the castle, in the yard directly behind the Hanging Corner.

Dodshon Foster
(1 September 1730–02 January 1793)

When we examine the legacy of the Georgian period and the slave trade in Lancaster, we cannot do so without also considering the role of the town's merchants. When we look at Lancaster's history during this period, there were several important merchants, one of which was Dodshon Foster.

Dodshon was the son of a Quaker merchant from Durham, Robert Foster, and was born in 1730 in Hawthorne. Aged seven he inherited £900 from his great uncle, also called Robert Foster who had been a merchant in Rotterdam. In 1751, he inherited a further sum of £120 from his grandfather Nicholas Dodshon. Around this time, he began to take an interest in the slave trade and, partly due to his family connections to the Furness and Kendal area, decided to move to Lancaster.

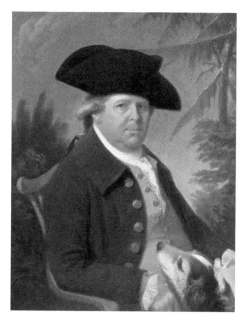

Painting of Dodshon Foster by William Tate.
(Courtesy of Lancaster Maritime Museum)

From the surviving records, we know that around 1752, he began to make investments in relation to the port and slave trade. One of his first investments was in a ship named the *Barlborough* with another merchant, John Heathcote. The ship was a brand-new vessel of around 40 tons, which was quite small for the time. From the records, we know the ship made successful voyages to Africa and the West Indies on four occasions between 1752 and 1757.

The records show that during this period around 550 slaves were transported to the West Indies; it was also possibly the first Lancaster ship to visit Jamaica. From the surviving record of the journey, we know that in 1753, the ship moored for 17 days and returned to Lancaster with 10 puncheons of rum. A year later in 1754, the ship stayed for 63 days and returned with goods, including 400 bags of ginger, 40 tons of mahogany and 23 bags of cotton.

Being a shrewd businessman, he also invested in a second ship again with Heathcote, the much larger *Bold* that undertook five successful voyages and would have ensured a large return on his investment. Through his involvement in the slave trade, it would have allowed him to become arguably one of the most important merchants in the town and also one of the youngest.

On 2 July 1753, he married Elizabeth Birket at the Friends' Meeting House. He subsequently had four children with Elizabeth, Robert (1754–1827), Jane (1756–1758), Myles (1759–1779) and Elizabeth (1764–1823). What makes this period very interesting is the heavy involvement of the Quakers in the slave trade, which, we know from the surviving records at the Lancaster Meeting House, was regularly discussed and scrutinised.

By 1755, his standing had grown so much that he was elected to the role of Port Commissioner with a key role in the management of the Port of Lancaster. In 1757, he had invested in the ship *Hawke* in a joint partnership with his father-in-law, and we know that this ship sailed between the West Indies and South Carolina the same year. However, shortly afterwards, we find that his interest in the trade was beginning to wane. In April 1758, his ship *Barlborough* was listed for sale; his friend John Heathcote had died in March and the trade was also beginning to suffer due to the Seven Years' War that was ongoing. Through his years of investment as well his marriage into a family with connections to the West Indies, he had new opportunities for trade that were outside of the mainstream slave trade.

Foster also worked with the Gillows company, and the records show us that in 1759 he supplied them with mahogany and also purchased completed pieces of furniture. Around this time, we also begin to find that his name does not appear that prominently on the records. We know that in 1766 his wife Elizabeth was in poor health and had gone to Bristol in the hope of getting better, sadly the same year Elizabeth passed away.

By 1772, Foster had decided that a move to new surroundings was necessary, and he chose to move out of his family home of twenty years in May the same year. Although he left the property, he did not sell it due to its location on the quayside and the

Dodshon Foster's signature. (Courtesy of www.benbeck.co.uk)

adjoining warehouse. In 1779, he received news that his son Myles was seriously ill, and he immediately set off accompanied by a doctor. However, they were too late and received news while travelling that his son had died. A year later, Foster suffered even more bad news when his grandson, Dodshon, who was named after him, passed away at four years of age.

Dodshon Foster himself died in January 1793 and was buried three days later next to his grandson at the Friends' Meeting House. His fortune and inheritance were passed down among his surviving children and family members, and his legacy still lives on not only through the development of the quayside but also through his prominent portrait in the Lancaster Maritime Museum.

G

Gillows

When we look at Lancaster's industrial past, there is one business that comes to mind and can be considered to be the first large-scale industry in the town; that business was Gillows of Lancaster. The company had humble beginnings in the town, but rapidly grew to become the leading furniture manufacturer in the area with a reputation for excellence in the quality of their furniture.

Robert Gillow began trading in Lancaster as a joiner, house carpenter and furniture maker and gained a popular reputation around the town for his work that allowed him a few years later in 1730 to form his business. Gillows made use of the many exotic woods that were being imported into Georgian Britain at the time, fuelled heavily by Britain's involvement in the slave trade. By the 1740s, the company had begun to take an interest in the triangular trade and purchased a one-twelfth share in a ship called *Bridget* that was used for the importation of mahogany from the British settlements in the West Indies. This venture was so successful that we know only a couple of years later in 1742, the company was exporting completed items of furniture back to the West Indies to furnish the lavish plantation houses and buildings of the British people living there.

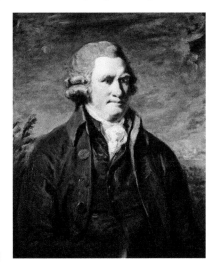

Painting of Robert Gillow. (Courtesy of Leighton Hall)

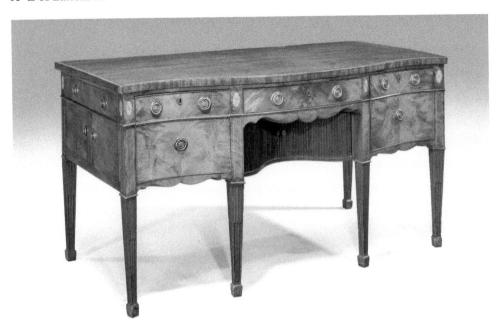

Regency Period Mahogany Library Breakfront Secretaire Bookcase, *c.* 1820. (Courtesy of Windsor House Antiques)

Robert Gillow decided to go into partnership with his son Richard on 1 January 1757, after which the company changed its name to Robert Gillow & Son. Apart from Richard's work with the Gillow company, he was also locally renowned for his architectural skills having worked on several local buildings, including the Lancaster Custom House. By 1768, Robert Gillow, who was now getting towards old age, decided to retire from the business. On 31 December, he finally retired, leaving his share of the company to his other son, also called Robert. As the company grew, the brothers decided to expand into new areas, and in 1769 the company opened a shop on Oxford Street, London.

By 1814, the Gillow family had decided that they no longer wished to run the company, and it was sold to a partnership of Redmayne, Whiteside and Ferguson. Under this new partnership the the Gillows name was retained and continued to expand the company from a designer and manufacturer of furniture to offering interior design skills and even to supply products from other suppliers. Outside of London, they became the largest company of this kind and had a great reputation for quality. Due to this reputation, they were often approached with commissions to decorate and furnish many important buildings around the world, including in Australia, France, Germany, Russia and the United States.

In 1897, the company was suffering financial difficulties and decided that to help alleviate this they would create an informal partnership with Warings of Liverpool, founded by John Waring in 1835. Six years later, Warings bought the Gillows company and merged to create Waring & Gillows. During the late 1930s and 1940s, they developed a reputation of creating elegant interiors on luxury yachts and cruise ships

Old Gillows Showroom on North Road. (Author's photograph)

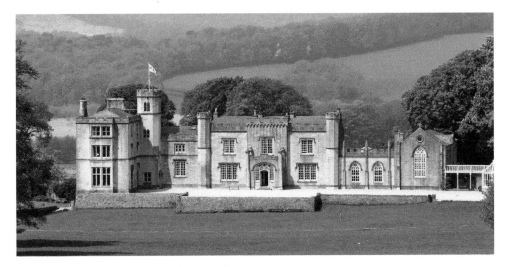

Leighton Hall. (Courtesy of Leighton Hall)

and worked on the *Queen Mary* (1936) and *Queen Elizabeth* (1946). During the Second World War, their factory produced ammunition chests and propellers. In addition to this, they created new factories making tents, gas masks and trench covers, as well as ammunition belts and protective clothing.

Unfortunately, by the 1960s, the company was in a rapid decline, and the workshops in Lancaster closed on 31 March 1962. Over the next few decades, the company name became part of various other companies, but it never regained the reputation that the company was built on. Although the company no longer exists, the name and furniture it produced is still held in the highest regard, and you can still find the original showroom on North Road, which to this day still displays the Gillows name prominently above the doorway. The family is now mostly known as being the owners of Leighton Hall that was purchased by Richard Gillow II in 1822 and is home to some notable pieces of Gillows furniture.

Thomas Harrison
(*c.* 7 August 1744–29 March 1829)

One of the most important architects to have worked in Lancaster is Thomas Harrison, and it is through his work in the Georgian Period that Lancaster gained some of its most iconic structures. As an architect, he is considered to have been a pioneer in Greek Revival architecture in the northwest with many of his works still surviving.

Thomas Harrison was the son of a joiner, also called Thomas, and was born in Richmond, Yorkshire, in 1744, the exact date is unknown. From the few surviving records, we do not know that much about his childhood and early life. We do know that he attended Richmond Grammar School and in 1769 travelled to Rome to attend the prestigious Accademia di San Luca to study classical architecture; this was made possible by the support of local landowner Sir Lawrence Dundas.

Harrison spent seven years living there, and during this time developed his skills for drawing and architecture, sketching many of Rome's iconic landmarks. His skill

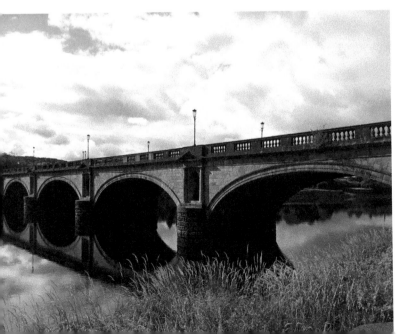

Skerton Bridge.
(Author's picture)

in architectural design had become so detailed that in 1770 he submitted an entry in a competition to design the conversion of the Cortile del Belvedere at the Vatican to house a museum of statues. Although his design was well received by Pope Clement XIV, it was rejected. Undeterred, three years later, he entered another competition, and this time it was a design for the replanning of the Piazza del Popolo, sadly again he was unsuccessful. He was disappointed with the outcome and petitioned the Pope; his plea was successful, and he was commissioned to come up with a new design for the Sacristy of St Peter's, however Pope Clement XIV died before the construction commenced, and the project did not go ahead.

Harrison returned to England in 1776. He had travelled back through France where he made several sketches of Paris and Nimes. Upon his arrival, he also created the designs for a new bridge and road in London that were declined, and by 1778, he could be found once again living in Richmond.

When we examine the work of Harrison, bridges play a key part in his professional career. One of the most important structures locally was Skerton Bridge. His professional career as an architect began in 1782 when he won the first prize in a competition to design the new bridge in Lancaster, as a result he moved from Richmond and set up in Lancaster. The new bridge was designed to cross the River Lune and act as a replacement for the old medieval bridge. After some minor changes, the first stone was laid in June 1783, and the bridge completed four years later in September 1787.

From the surviving records, we know that the bridge cost £14,000, which is approximately £1,600,000 today. What makes Skerton Bridge notable is that it is supported by five elliptical arches and was the first bridge in England to have a flat road surface. Due to the success of Skerton Bridge, Harrison was commissioned to build many other bridges around the country, including Stramongate Bridge in Kendal between 1791 and 1794. Unofficially, he was given the title of Bridge Master of Lancashire and Cheshire, and his Cheshire post became official in 1815 when he was legally appointed to the role.

Thomas Harrison married Margaret Shackleton in 1785 at Lancaster Priory and together they had three children. During his time in Lancaster, he became well known for his work and was commissioned to undertake other projects within the town. One of the most important was the improvement and redevelopment of Lancaster Castle. In October 1786, Harrison was asked to prepare plans for substantial improvements to Lancaster Castle; he had also just won a competition for major improvements at Chester Castle. As part of the redevelopment of Lancaster Castle, he had to create new buildings within the confines of the castle walls and existing structures. Over the next 30 years, he worked simultaneously on Lancaster and Chester Castles.

Construction began in 1788, and the first structure to be finished was the new Keeper's House located on the right side of the imposing gatehouse. Subsequently, work continued, with the Female Prison being completed next. Other constructions included

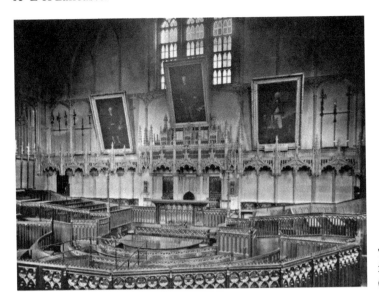

The Shire Hall, 1927, from an old postcard. (Author's collection)

the Male Prison located north of the keep, two additional floors of accommodation for debtors and an arcade around the south side of the keep to provide shelter from the rain. He incorporated new ideas of the time into his designs, especially the separation of prisoners by sex and by keeping debtors separate from criminals. From the records, we know that by 1794, the cost of the improvements had exceeded the final estimated cost and totalled £10,853.

By 1795, Harrison had moved to Chester but continued to supervise both sites. The next major task was the rebuilding of the Crown Court and the Shire Hall at Lancaster Castle. In this period, the original Crown Court took place in the medieval hall of the castle, and civil cases were held in the Shire Hall in the keep. These were completed in 1798, however the finishing internal decorations and furniture took several more years and were completed by English artist Joseph Gandy.

These two structures have a very varied design: the Crown Court is in the form of rectangular room, whereas the Shire Hall is in the shape of a half polygon with lavish Gothic columns supporting a panelled vault. The cost of these two structures is unknown, but in 1807, an estimate suggested that it cost at least £40,000. As well as his important works on Skerton Bridge and Lancaster Castle, he also constructed bridges, houses on the east side of Skerton Bridge that acted as a toll bridge and provided housing, the clock tower at the old town hall, Springfield Hall (demolished in 1862) situated on the site of the Royal Lancaster Infirmary, Quernmore Park Hall and created the additional tower and spire at St John's Church.

In his later years, he continued to undertake many projects from manor houses and churches to private clubs. His work can be found throughout the north of England with many notable examples still in existence. He died in Chester in 1829, leaving an inheritance of £6,000 and was buried at St Bridget's Church in Chester.

Tower and spire at St John's church. (Author's photograph)

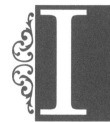

Inns and Taverns

When we examine the history of the town and some of its older buildings, we are lucky that many of the original inns and taverns survive. These unassuming places were once the thriving hub of the town and its port where deals would be made, ships bought and sold and tales of exciting journeys recounted. These places can be seen as more than a place for drinking; they would often produce their own beer

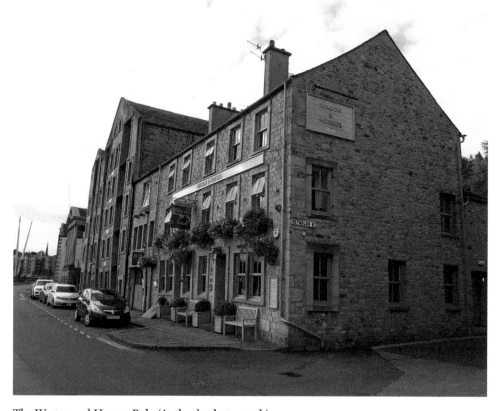

The Wagon and Horses Pub. (Author's photograph)

The Sun Inn.
(Author's photograph)

and provided additional services from accommodation for weary travellers to stables for horses.

The people who ran these establishments were generally men who often became as well known as the places that they ran; they developed varying reputations from hospitable hosts to sleazy rip-off merchants. It was an acceptable vocation for women to become barmaids who were always happy to provide an ear to clients and also flirt with them. However, it was generally frowned upon for women to visit such establishments and for those who did visit, their reasons would often be evident from the trade they were plying.

In Lancaster, especially during the Georgian period, the hub of the town centred around the quayside. During this period, the river area developed an unsavoury reputation for criminals, petty theft and prostitutes. If you visit the area close to the quayside nowadays, you will still find a few of these original pubs, including the Wagon and Horses and Three Mariners; these are known to have been popular establishments during the height of the Port of Lancaster.

Another important pub in the centre is The Sun Inn that has a history dating back to at least 1680. It once had housed separate stables and in 1767 was recorded as also

having a bowling green. The original building was rebuilt 1785 due to the poor state it was in. Towards Castle Hill, you come across The Merchants that is located in an old cellar complete with vaulted ceilings, and the impressive building of The (Royal) King's Arms that was used by merchants and officers from the port to conduct their business.

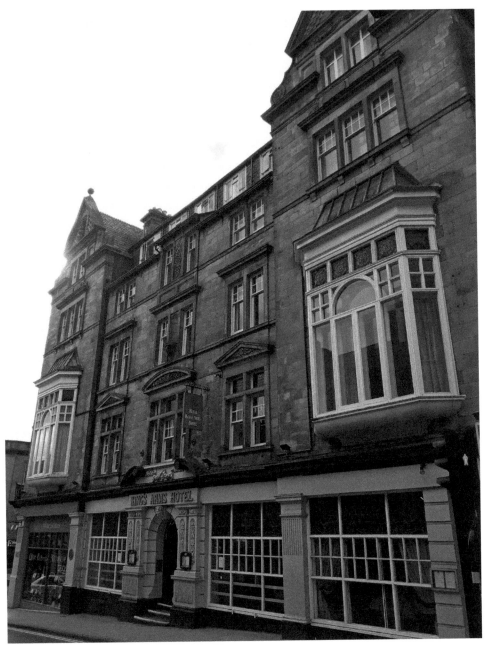

The (Royal) King's Arms Hotel. (Author's photograph)

J

The Judge's Lodgings

Another important building when we look at the history of Lancaster is the Judge's Lodgings, a building not just with its own history but also one that is closely tied with the history of the castle. The building is the oldest existing townhouse in Lancaster, with remains of buildings at this location possibly tracing back to a Roman kiln. Later evidence also points to a building of wooden construction dated to around 1314 existing on the site, likely the home of English nobleman, Robert de Holland.

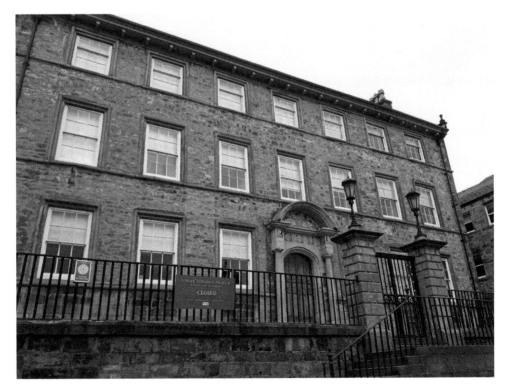

The Judge's Lodgings. (Author's photograph)

The current building dates from around 1625. It was constructed using timber from the original building and even houses a stone fireplace that dates from around 1550. The most important period of the building's history came when the house was owned and redeveloped by Thomas Covell (*c.* 1561–1 August 1639), a man who is not very well known nowadays. During his lifetime, he was a well-known local and held several important jobs in the city, including becoming mayor six times, keeper of Lancaster Castle, magistrate and coroner. Arguably, his most important role was that of keeper of Lancaster Castle from 1591 until 1639, and during this period, he would have overseen the imprisonment of the Pendle Witches. The building was used as early as 1635 for accommodating visiting judges who were in Lancaster as part of the Assize courts. He married Dorothy Watson, who in 1601 gave birth to a girl, Elizabeth. There are records of him also having a son named Phillip, but we do not have any more records for his son. He remained involved in the town for the rest of his life, and one interesting piece of information that we do have relates to the day before his death, when he quickly drafted a will, asking to be buried in Lancaster Priory.

During the Civil War, Lancaster was severely damaged by Royalists in 1643. Around twenty years later, in 1662, the property was bought by the Deputy Lieutenant of Lancashire, Thomas Cole. The building underwent extensive alterations in 1675. By 1826, the house was once again sold, this time to the county magistrates and once again underwent alterations. The use of the house by judges ended in 1975, and the building was developed into the current museum. The Judge's Lodging is also home to one of the best collection of Gillows furniture as well as a collection of paintings, including the work of Furness-born George Romney.

King's Own Royal Regiment

The King's Own Royal Regiment served the British Army as a line infantry regiment from 1680 until 1959. They served in many important conflicts, including Waterloo, the Second Boer War and the First and Second World Wars. The foundations of the regiment can be traced back to 13 July 1680 when it was first raised by Charles FitzCharles, 1st Earl of Plymouth, under the title of the Earl of Plymouth's Regiment of Foot, also known as the 2nd Tangier Regiment. The regiment served as part of the standing army of King Charles II to assist in to garrisoning the Colony of Tangier.

It saw its first battle at Sedgemoor in 1685 while defending King James II's throne from the claims of James Scott, 1st Duke of Monmouth. When the regiment was under

King's Own Cap Badge. (Author's collection)

the control of Col Charles Trelawny, it was the first regiment to change their allegiance to Prince William of Orange when first he landed in Torbay on 5 November 1688.

A year later in January 1689, James II had fled to France, and William ascended to the throne as King William III. Through their new allegiance, the regiment served with William's army against James II and his French allies in Ireland. On 11 July 1690, the regiment fought at the Battle of Boyne and also took part in and the sieges of Cork and Kinsale in 1690 and Limerick a year later. By 1692, the regiment had joined with William's forces in Flanders, Belgium, to fight against the French, and in the same decade, they also fought at the siege of Namur (2 July–1 September 1695) during the Nine Years' War.

In 1704, the regiment once again saw action on the continent, this time during the capture of Gibraltar (1–3 August 1704) and its defence until May 1705. In July 1715, King George I conferred on the regiment its new title of The King's Own Regiment of Foot. In 1745, the regiment joined Gen. Wade's army in pursuit of the Jacobite army of Charles Stuart. Fighting at Clifton Moor and Falkirk preceded the decisive Battle of Culloden on 16 April 1746, where the regiment bore the brunt of the Highlander's initial charge. The regiment remained in Scotland until 1751 and was styled The 4th, or King's Own Royal Regiment the same year. Between 1753 and 1756, the King's Own

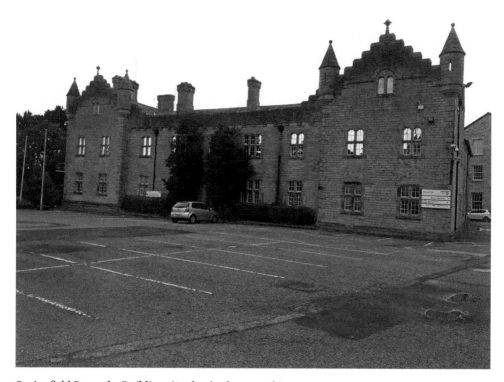

Springfield Barracks Building. (Author's photograph)

were stationed on Minorca, and a 2nd Battalion was also raised in 1756 that two years later became the 62nd Foot (Wiltshire Regiment).

The Regiment served during the Peninsula War (1808–1814), fighting the armies of Napoleon, afterwards they were moved to North America in May 1814 and took part in the fighting at Bladensburg and the first assault against New Orleans. They later returned to Europe and took part at the Battle of Waterloo on 18 June 1815 where the regiment held a central position and played an important part in the victory. They remained in France after the battle and did not return until 1818.

Later in the nineteenth century, the regiment served in Australia from 1831 to 1835. During the 1870s, they served in India returning in 1848 and participated in the Crimean War (1853–1856). In 1856, a new purpose-built barracks known as Springfield Barracks was built for 1st Royal Lancashire Militia, and a year later, during the Indian Rebellion (1857), they were once again called up to assist but due to a shortage of troops, a 2nd Battalion had to be raised that was stationed in Chichester. The 1st Battalion was asked in 1868 to help free some Europeans who were being held captive in Abyssinia, modern day Ethiopia, by Emperor Theodore. When the regiment arrived, they marched to the fortress of Magdala, they won the Battle of Arogie, the fortress fell and Emperor Theodore killed himself.

In 1873, the War Office purchased land on the Bowerham Estate and set about constructing a barracks between 1876 and 1880. This provided accommodation, stables, an armoury and all the usual facilities for an army unit. The 1st Battalion moved from Springfield Barracks to Bowerham Barracks in 1883 when it became the 3rd and 4th Militia Battalions of the King's Own Royal Lancaster Regiment. Under the

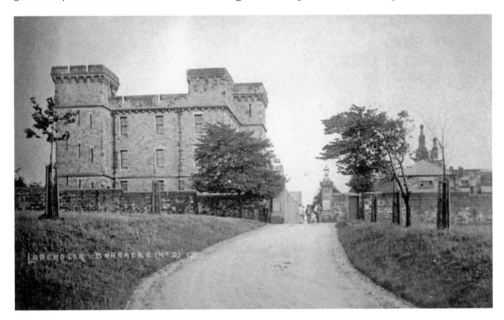

Bowerham Barracks from an old postcard. (Author's collection)

Cardwell Reforms, the regiment avoided amalgamation but was allocated a territorial connection for the first time and renamed The King's Own (Royal Lancaster Regiment). The 2nd regiment embarked for South Africa in December 1899 to serve in the Second Boer War (1899–1902), at the same time a 3rd Battalion was created that travelled to South Africa in February 1900.

Over the next decade, the battalions continued their cycle of transferring between outposts across the empire. By the start of the First World War in 1914, the King's Own comprised of two Regular and two Territorial Battalions and a Special Reserve Battalion, but by 1918, it had expanded to seventeen battalions. Around 44,000 men served with the regiment during the war with losses numbering almost 7,000.

The 1st Battalion was called upon in August and fought on the Western Front, the 2nd Battalion also served on the Western Front from January to November 1915, later moving onwards to Greece. The 4th and 5th Battalions were called up in August 1914 and tasked with protecting British soil before leaving for the Western Front. The 5th Battalion was transported in February 1915 with the 4th Battalion going in May 1915. The 3rd Battalion was also mobilised in August 1914 when it aided in training thousands of men who had enlisted for service. Additional battalions in the shape of the voluntary battalions were also formed in 1914; these served not only on the Western Front but also in Iraq and Eastern Europe. One of these was the 11th Battalion, nicknamed the 'Bantam Battalion' due to accepting men who were below the official minimum height.

In 1919, not long after the end of the First World War, the 1st Battalion was in Dublin and the 2nd was sent to India and Burma and spent the next ten years on service abroad. In 1921, the regiment was redesignated the King's Own Royal Regiment

Cigarette Card with the King's Own Emblem, 1907. (Author's collection)

(Lancaster). In October 1930, the 1st Battalion was once again transferred to India, Palestine, Egypt and would not return to Britain until 1950.

The regiment was once again called up for active service during the Second World War, fighting in France and Belgium as well as in the Middle East. One of the worst events during the war occurred in 1943 while the 1st Battalion was fighting in Leros, Greece, where heavy fighting almost destroyed the unit. The survivors travelled to Palestine and merged with the 8th Battalion.

Due to the lack of men in the country during the Second World War, there was looming threat of a German invasion, and in September 1938, it was decided that the Women's Auxiliary Territorial Service should be created. They were tasked with carrying out non-combat duties, although they were expected to train in the same way as TA members, and assist around the base. There were two Women's Auxiliary Territorial Service units who trained at Bowerham Barracks, and they were affiliated to the 5th Battalion. At the end of the Second World War, all the units that had been formed during that period were disbanded.

In 1953, the regiment was awarded the Freedom of Lancaster for their service, and during 1953–1954, they were stationed in South Korea following the Korean War (1950–1953). Within a few years, they had been joined with the border regiment to form the King's Own Royal Border Regiment in 1959, which itself joined with King's Regiment (Liverpool and Manchester) and the Queen's Lancashire Regiment to form the new Duke of Lancaster's Regiment (Kings, Lancashire and Border) in 2006.

River Lune

When we look at the local landscape in the area, there is one feature that has played a major part in local history, that of the River Lune. The Lune has shaped the way Lancaster and the local district has developed throughout the centuries, serving as a vital artery to Morecambe Bay and the Irish Sea. It has provided food, power and a route for transport, allowing cities, towns and villages to thrive in the process. The source of the river originates not in Lancashire but in Cumbria, at Wath, located in the parish of Ravenstonedale.

The river is formed at the point where Weasdale Beck and Sandwath Beck meet. As the river moves downstream along its forty-four mile route, it passes through many ancient sites, including the remains of a Roman fort close to Low Borrowbridge, through the Lune Valley and Lancaster out towards the Lune estuary where it meets

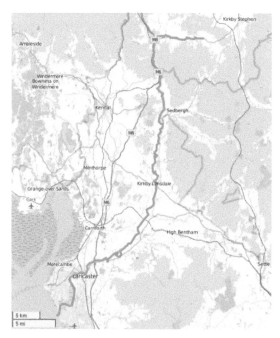

Map showing the route of the River Lune. (Courtesy of openstreetmap.org)

the sea at Plover Scar. Originally, the Lune was a tidal river, however, since the construction of Skerton Weir, the river can no longer travel further inland at high tide.

The river has several notable bridges and an aqueduct. In the centre of Lancaster, you will find four important bridges that cross the river. The furthest inland is Skerton Bridge, which has been discussed in my earlier chapter. If you move downstream, you will then come across Greyhound Bridge. Although now a major road bridge, it was originally constructed of wooden timbers to carry the Morecambe Harbour and Railway line to the coast in 1848. This was replaced during 1862–1864 by a new train bridge built using iron, and again replaced in 1911. When the railway line was closed in 1966, the road was converted to accommodate road vehicles, reopening in 1972 and serving as the main bridge between Lancaster and Morecambe.

Close to Greyhound Bridge, you will also find the unusually shaped Lune Millenium Bridge with its 'V' shaped arms; the bridge was built to celebrate the millennium and cost £1,800,000. It is the only dedicated foot-and-cycling bridge in Lancaster, and its location is also symbolic, as it marks the location of the old medieval bridge that once crossed the River Lune.

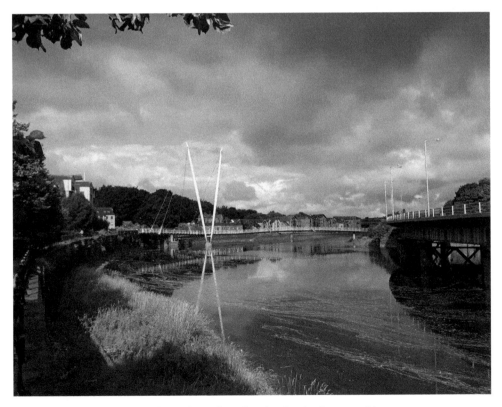

Lune Millennium Bridge and Greyhound Bridge. (Author's photograph)

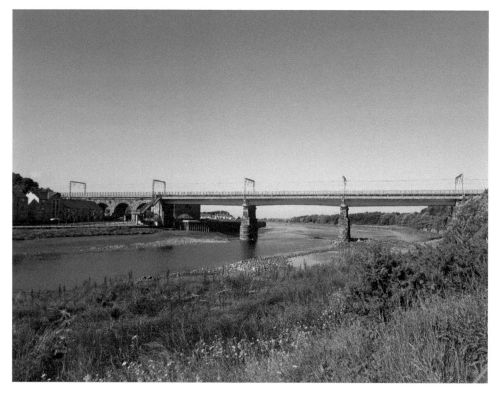

Carlisle Bridge. (Author's photograph)

The final bridge in the town centre is the imposing Carlisle Bridge that carries the West Coast Mainline across the River Lune on its journey northwards. The original bridge was constructed between 1844 and 1846 and opened in 1847. It underwent alterations in 1866 when the timbers used to span the supporting pillars were replaced with iron, with them once again being replaced with concrete and steel between 1962 and 1963.

All of these bridges serve as a vital connection between the north and south sides of the river and have allowed Lancaster, over the centuries, to become an important hub, well connected to the surrounding area and nationally.

M

The Music Room

One of the finest but least know buildings in Lancaster has to be the Music Room. Despite what the name implies, it was not used for music but instead derives from the decorative baroque plaster work depicting nine Muses that adorn the upper floor or 'Muses Room'.

The room is adorned with elaborate plasterwork depicting Zeus and Mnemosyne's nine daughters, also known as the Muses. They were considered to be inspirational goddesses of the arts, literature and science and are Calliope (epic poetry), Clio

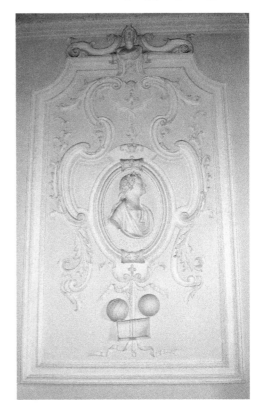

Plaster work detail of Urania. (Courtesy of Humphrey Bolton)

(history), Erato (love poetry), Euterpe (music, song and lyrical poetry), Melpomene (tragedy), Polyhymnia (hymns), Terpsichore (dance), Thalia (comedy) and Urania (astronomy). Apollo is depicted above the fireplace, and Ceres is shown on the ceiling. The building was used as a space for viewing the garden, with the first floor being used by guests who wished to view the formal garden design from a higher vantage point.

Unfortunately, records for the early development of the building are very scarce. The name of the architect has been lost to history, however we do know that around 1730, the building was erected, probably to serve as a garden pavilion for Oliver Marton who had made his money as a lawyer for the Middle Temple in London. Marton resided at No. 76 Church Street, which he had purchased in 1723. We know that in addition to the garden of his house, he also owned a much larger piece of land located behind The Sun Inn.

From the surviving historical records, we cannot tell who was responsible for the design and creation of the plaster work, although some evidence points towards Francesco Vassalli, an artist known for his ornate stucco plaster work that he had been creating in many great houses across Lancashire during the 1730s. Upon the death of Oliver Marton in 1744, the property passed to his eldest son Edward. When Edward died in 1758, having no children of his own, the building and gardens passed to his brother Revd Dr Oliver Marton, a local vicar and owner of Capernwray Hall. After the death of Revd Dr Marton, the garden was sold as land for development, and sadly by the end of the eighteenth century, buildings had been erected very close to the Music Room.

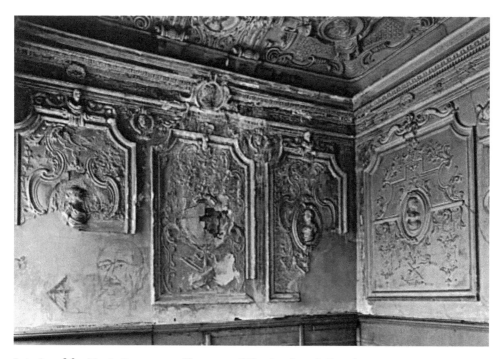

Interior of the Music Room, 1957. (Courtesy of The Landmark Trust)

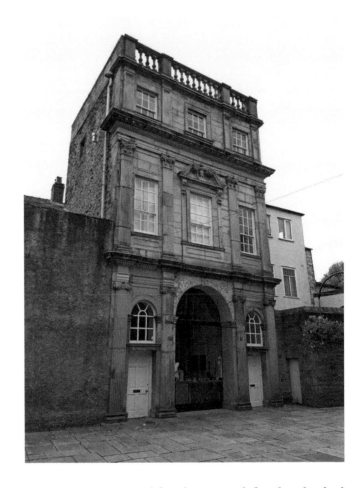

The Music Room.
(Author's photograph)

Over the next century, the building was owed by the Seward family who had established a successful ironwork and stained glass business on Church Street in 1778. The building continued to fall into decline and fell into a poor state of repair. The business went into liquidation in 1934, and the land was sold. In the 1950s, it was resold again and was purchased by the Willans family, but only twenty years later during the 1970s, the building was once again in a terrible state.

The Landmark Trust purchased the site and attempted to restore the building to its former glory. The interior of the building was in a state of neglect, and the ornate plaster work was in danger of being lost. Over the past century, surrounding buildings had been built up against the Music Room, and these were also purchased by the trust and eventually demolished. The façade was carefully cleaned and repaired, and the roof was replaced. Most important was the work undertaken in the main room, the plaster work was repaired and restored, taking over 6,000 hours to complete. Since the restoration, it is now possible to stay in the upper rooms, and the ground floor currently houses a small café, ensuring that this ornate and unique building will be part of Lancaster architecture for many years to come.

Elizabeth Nelson
(1 December 1835–12 January 1866)

Arguably, one of the least-known murders to have occurred in Lancaster was the Scotforth murder in 1866. It was well reported at the time in the local newspapers, including the *Lancaster Guardian* and *Lancaster Gazette*, as well as other northern newspapers, but over the past century seems to have been forgotten. The murder occurred at the southern end of Scotforth on the outskirts of Lancaster, with the present day location on the Lancaster University campus.

On the morning of 12 January 1866, Thomas Wilkinson from Wilson House Farm set off with his cart to collect straw from Hazelrigg Farm. The ground was still covered with snow, and he travelled south along the main road from Lancaster to Preston. His route took him left near Oubeck House and onto Chapel Lane that led to Ellel Chapel. At the top of the hill, he turned onto a track known as Green Lane, which was a shortcut to Hazelrigg Farm.

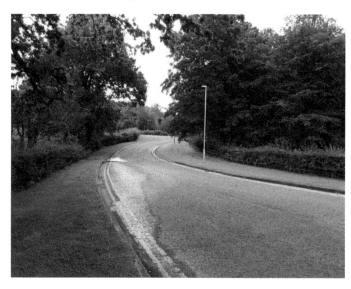

Entrance to Chapel Lane.
(Author's photograph)

After travelling around 100 yards, he came upon a body by the roadside. The body was lying on its back, and fully clothed. He immediately turned back to find somebody to report his discovery to. He came upon retired farmer John Parkinson who lived nearby, and together they returned to the scene to see whether the victim was male or female, shortly afterwards John Parkinson set off to Galgate to get the police. Sgt John Harrison travelled to the scene with John Parkinson; they were also accompanied by Revd Thomas Stedman Polehampton.

Upon examining the scene, it was clear that there was not much evidence. The lack of snow underneath the body suggested that the body had lain there before the heavy snowfall that fell around 8.00 p.m. the night before, and it also became clear that it was the body of a young woman, later identified as Elizabeth Nelson. The body was taken to the nearby Boot and Shoe Inn in Scotforth, where the body was washed. During this cleansing, it became clear that the body had many more injuries than had first appeared, and heavy bruising was discovered. There was also a large amount of blood on her clothes, especially on her undergarments that suggested she may have suffered internal injuries; this indicated that she had been sexually assaulted and murdered.

Elizabeth's body then underwent a post-mortem by Dr William Hall, a local surgeon. He noted that there were four main areas of trauma; these were to the head, arms, legs and torso. It was also clear that there were pressure marks on her neck, swelling of her face and protruding eyes that were consistent with strangulation. Upon examination of her lower body, it became apparent that she had suffered significant internal injuries, an internal tear allowed part of bowel to shift and resulted in heavy blood loss as the result of the sexual assault.

The victim was Elizabeth Nelson, a maidservant who was working for Mr Whalley of Richmond House. On the evening on 11 January around 5.30 p.m. she left the house; she said she needed to go to the post office to drop off a letter, and afterwards she had arranged to take back a bonnet that she borrowed from Mrs Rebecca Barrow. We

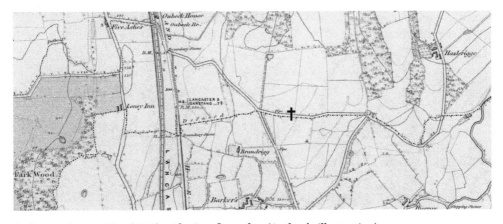

Ordnance Survey Map (1848) with site of murder. (Author's illustration)

The remains of Green Lane.
(Author's photograph)

know from the records that it was dark, cold and the weather was beginning to turn, and she set off wearing a black dress, bonnet, gloves, veil and shawl.

We know that at 6.15 p.m. she arrived in Middle Street and gave Mrs Barrow her bonnet back before setting off again. Although it was noted that she was not home at Richmond House, no one had thought anything of it as she often stayed overnight with her ill mother. The next morning, Adam Lund, who also worked at Richmond House, was sent to Elizabeth's mother's home, and he discovered that she had not stayed there overnight. Shortly afterwards, he went to the police to report her as missing; he was then taken to identify the body that had been discovered that morning.

Over the next few days, the police tried to track down any witnesses to the murder and also re-examined the crime scene. They came across a set of false teeth that belonged to the victim in addition to an unopened letter. The only person to come forward was John Welch who stated that while on his way back from Lancaster towards his home, he had noticed a woman by the side of the road, but she was obscured by the shadow, meaning that he was unable to identify her. The murder provided a source of gossip in the village, and very quickly two local men were arrested; they were Joseph Dunderdale and John Cottam. Cottam's clothes were confiscated, and there appeared to be traces of blood on his trousers and handkerchief as well as a bloody fingerprint in one of his pockets. The two men had claimed to have been out together on the night of the murder but were unable to

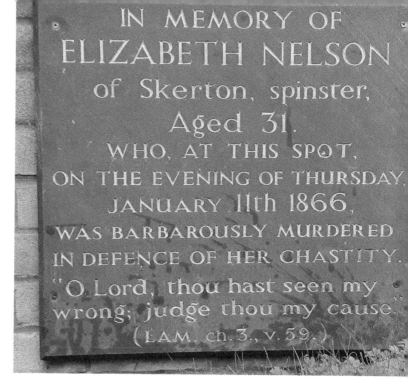

IN MEMORY OF
ELIZABETH NELSON
of Skerton, spinster,
Aged 31.
WHO, AT THIS SPOT,
ON THE EVENING OF THURSDAY,
JANUARY 11th 1866,
WAS BARBAROUSLY MURDERED
IN DEFENCE OF HER CHASTITY.
"O Lord, thou hast seen my
wrong; judge thou my cause."
(LAM. ch. 3., v. 59.)

Memorial plaque.
(Author's photograph)

give an account of the timings, and due to their statements, Joseph Dunderdale was released as the police found him to have a reasonable alibi, whereas John Cottam remained locked up.

The main question surrounding the murder of Elizabeth was why she had been travelling in the dark around a fairly remote area; it has been suggested that she may have been lured by someone she knew. Around the time of the murder, new information became known, and it was alleged that a similar attack had occurred the previous year on 20 October 1865 when a young woman who was walking in the area was attacked from behind, luckily on this occasion the attacker was disturbed by someone else passing close by, and the attacker ran away. On this occasion, the victim was unable to identify who had attacked her. The police continued to investigate with statements given by various local people suggesting that John had known Elizabeth, which he continued to deny.

A court case was held on 22 January at which Cottam was questioned. The bloodstains discovered on his clothes were analysed by Dr Roberts who was unable to confirm that the blood was Elizabeth's. Evidence came to light that John suffered from a skin disorder that caused him to scratch at his skin, making it bleed. A couple of weeks later, on 7 February a final hearing was held; the conclusion of the court was that there was insufficient evidence to convict John Cottam, who was subsequently released.

The identity of the murderer was never discovered, and to this day the case remains unsolved. Elizabeth was buried in Aughton, close to Halton where her gravestone can still be seen. Another reminder of the crime can be found at Lancaster University in the grounds of Grizedale College not far from the scene of the crime where you can find a small memorial plaque.

Richard Owen
(20 July 1804–18 December 1892)

Sir Richard Owen is perhaps one of the least-known Lancastrians who also provided one of the most important scientific developments of the nineteenth century. Richard was born in Lancaster on 20 July 1804, to Richard Owen, a merchant, and Catherine Parrin. His family were not very wealthy, and he was one of six siblings. His family situation was made worse when, aged five, his father passed away. Luckily while growing up, Richard had the chance to attend Lancaster Royal Grammar School. Shortly after finishing at school, he enlisted in the Royal Navy as a midshipman, and while serving he developed a keen interest in surgery, deciding to come back to Lancaster to pursue a career in the medical profession.

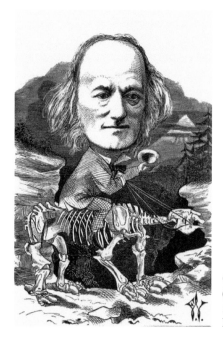

Cartoon of Richard Owen 'Riding His Hobby'. (Waddy, F. *Cartoon Portraits and Biographical Sketches of Men of the Day*. London: Tinsley Brothers, 1873)

In 1820, he became an apprentice to a local surgeon, and four years later, he travelled to Edinburgh to continue his interest as a medical student at the University of Edinburgh. In 1825, he left the university and completed his medical course in London at St Bartholomew's Hospital. While in London, he developed a friendship with John Abernethy, the eminent surgeon.

Ten years later in July 1835, he married Caroline Amelia Clift with whom he had a son, William Owen. When Richard finished his studies, he decided that he would rather continue research in the field of anatomy than become a full-time doctor. His old friend Abernathy helped him to gain a position as the assistant to William Clift, who was responsible for the curation of the collections within the Royal College of Surgeons. A year later, his hard work had paid off, and he was given a role as Hunterian professor, eventually taking the role of conservator from 1849 to 1856. It is through his early work that we see his interest in anatomy begin to flourish, and during his tenure, he was responsible for creating a series of catalogues of the collection, and this allowed him in turn to gain a huge insight into the field of anatomy and also help him in his research into the remains of the now-extinct animals.

When an opportunity arose, he would also dissect fresh subjects, and his reputation allowed him to examine all animals that died in London Zoo. The zoo began to publish scientific papers in 1831, and he became a frequent contributor. His first notable work was *Memoir on the Pearly Nautilus* published in 1832, for which he became well known and respected. Throughout his career, he always supported men of science and preferred to keep the status quo within the field. As his reputation grew, he was rewarded for his efforts. He was given a cottage in Richmond Park by the royal family, and Prime Minister Robert Peel put him on the Civil List to receive money from the government. His reputation also gained notice abroad, and in 1843, he was elected as a foreign member of the Royal Swedish Academy of Sciences.

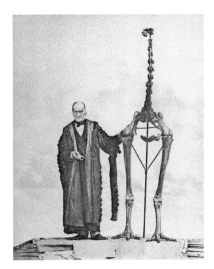

Owen with a giant moa skeleton. (Owen, R. *Memoirs on the Extinct Wingless Birds of New Zealand: Vol 2.* London: John van Voorst, 1879)

However, throughout his career, he was often accused of putting his name to the works of other people or failing to credit his sources. In 1846, he published a paper for which he won the Royal Medal. His work on an extinct cephalopod known as a belemnites while detailed and factual failed to address the point that they had in fact been discovered by Chaning Pearce, an amateur biologist, who had made the discovery four years earlier. Unfortunately for Owen, his failure to accurately acknowledge this resulted in him being voted off the councils at both the Royal Society and the Zoological Society.

Throughout his career, he always sought to make contributions to the knowledge of comparative anatomy and zoology and published many papers and books over a period spanning fifty years. His work in these fields meant he was often the first scientist to describe and record these species and specimens. In 1852, he published a paper describing the oldest footprints found on land, and through his knowledge of anatomy, he correctly identified them as being made by an extinct arthropod, even though it would take scientists another 150 years to discover preserved fossils of it. Most of his works tended to focus on vertebrates rather than invertebrates. One of his most important publications was *Comparative Anatomy and Physiology of Vertebrates*, which he published in three volumes between 1866 and 1868, but he still took a keen interest in studying the remains of extinct groups.

One of his least-known, but arguably most important, contributions was his work on dinosaurs. It was Owen who first published an account of the great group of Mesozoic land reptiles. He should be acknowledged for the fact that he created the descriptive term 'Dinosauria', which is derived from the Greek words *deinos* (terrible, powerful) and *sauros* (lizard). Through his work on dinosaurs, he split them into three distinct groups: carnivores, which he called Megalosaurus; herbivores, called Iguanodon; and the armoured Hylaeosaurus. He also helped to create the world's first life-size sculptures, and with the help of Benjamin Waterhouse Hawkins, his creations came to life. A few of the models were originally made for the Great Exhibition in 1851 but

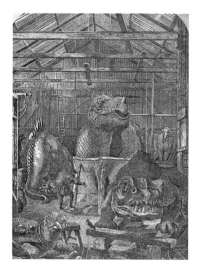

Benjamin Waterhouse Hawkins's studio in Sydenham. (Author's collection)

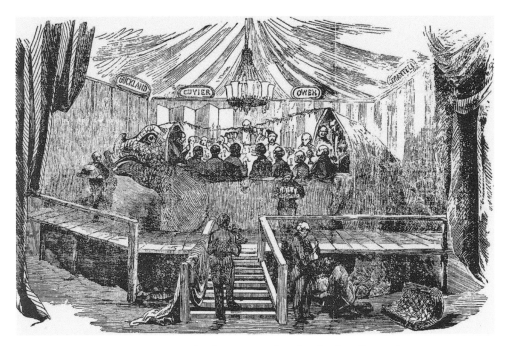

Banquet in the mould of the Crystal Palace Iguanodon. (Author's collection)

eventually created a collection of thirty-three models when the Crystal Palace was moved to Sydenham, South London. One of the most famous events surrounding the creation of the dinosaurs was when Owen hosted a dinner for twenty-one prominent scientists inside the hollow Iguanodon model on New Year's Eve 1853.

In 1856, he was offered the post of superintendent of the Natural History Department at the British Museum. During his tenure, he spent much of his time creating a scheme for the foundation of a National Museum of Natural History, eventually resulting in the removal of the natural history collections of the British Museum to the newly constructed building in South Kensington in 1881.

Owen is also famous for having a somewhat bitter rivalry with fellow scientist Charles Darwin. On 29 October 1836, he was introduced to Darwin by Charles Lyell, the most respected geologist of the time. Owen agreed to work on fossil bones collected by Darwin in South America, and his investigations led him to believe that the bones were of extinct rodents and sloths, but importantly also showed that they were related to current species in the same area, instead of being related to similarly sized animals in Africa, an idea that Darwin had originally thought of. It was this discovery by Owen that influenced Darwin's later ideas of natural selection. Over the next few decades, their differences in scientific thought began to widen.

Darwin sent Owen a copy of his book *On the Origin of Species* upon its publication in 1859. Owen was one of the first to commend the book, stating that it offered a suitable explanation when examining how a species developed. Through his role at the British Museum, he also received many enquiries and also complaints regarding Darwin's

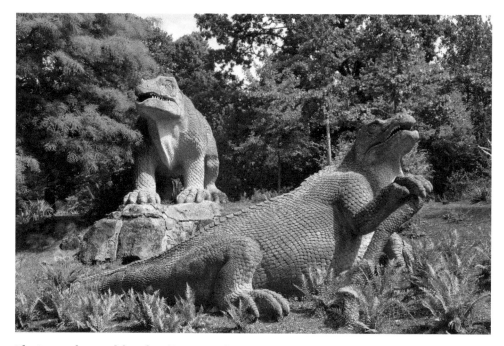

The Iguanodon models today. (Courtesy of Ian Wright)

work. In 1860, the *Edinburgh Review* published an anonymous review that Owen had written on Darwin's book; his review was scathing. Owen and some of the scientists close to Darwin continued to trade blows over the next few years, attempting to smear each other's reputations where possible. Owen began to gain a poor reputation within the scientific community due to his tactics in dealing with other scientists and his lack of judgement in his publications, and it has been also suggested that his rivals may have further encouraged this.

Owen continued working after his official retirement at the age of 79, but he was unable to recover from the damage caused to his reputation. He spent his eventual retirement at Sheen Lodge in Richmond Park where he passed away on 18 December 1892.

To this day, Owen has a somewhat distorted reputation and is significantly overshadowed by the work of his rival Charles Darwin. One reminder of his contribution to science is the statue of Owen located at the Natural History Museum, close to the statue of Darwin. Owen's legacy also remains in the recently restored monumental models of dinosaurs in Crystal Palace Park. Even though they are now seen as inaccurate depictions, they still serve as a reminder of the fascination that scientists and the public have with the lost world of prehistoric creatures.

P

Lancaster Priory

Another prominent structure on the Lancaster skyline is Lancaster Priory, also known as the Priory Church of St Mary, an imposing church that has been located atop Castle Hill for over 900 years. It is located within the old boundaries of the Roman fort that was erected during the Roman occupation and sits on the site of an earlier Saxon church that was built around AD 636.

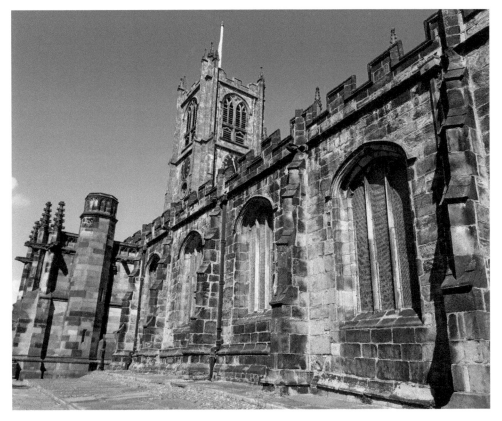

The Priory. (Author's photograph)

The current church was established in 1094 as a Benedictine Priory dedicated to St Mary and part of the larger abbey of St Martin of Sées in Normandy, France. From the surviving records, we know that the church also provided space for twenty people who wished to claim 'sanctuary', a common practice until the seventeenth century, in which the fugitives or people escaping for the law were immune from arrest. The priory was the creation of Roger de Poitou who owned the Lordship of the area, known as inter Mersam et Ripam, translated as between the Mersey and the Ribble.

The church worked closely with the Vatican and the Pope in Rome, and in 1133, the Abbot of Sées met with the Pope to discuss the collection of tithes in Lancaster. The Pope confirmed the right for the Prior of Lancaster to collect taxes in order to provide money for the purchase of the monks' food. Sixty years later in 1193, Lancaster was for the first time granted a charter by John, in the absence of his brother King Richard. The charter allowed for the establishment of a market and fair within Lancaster.

Not much is known about Lancaster over the next century, and it is not until 1349 and the Black Death that we find many documents relating to the priory. From the few surviving documents, we know that during the Black Death when the plague was sweeping the country, around people 3,000 died in Lancaster. We also get an insight into the effect that this had on the church with the incoming money from taxes dropping heavily. It would have taken several years to recover from this, and in around 1360, there was enough money to widen the nave within the church.

The biggest changes for the church were to come over the next hundred or so years. In 1414, Henry V gave control for the running of the church to the Bishop of Durham and changed its allegiance to the Brigittine Convent of Syon, Middlesex. By 1430, the priory had become very important within the district and so became the official parish church. This change also had some binding rules connected to it; the first vicar of Lancaster was appointed on 1 March 1430 and was a Richard Chester. The vicar under the new regulations was bound to live in the parish and had to

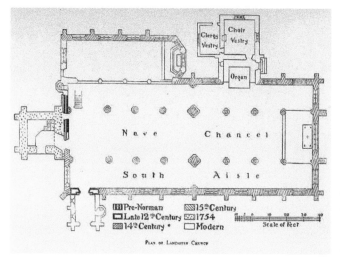

Plan of Lancaster Priory showing phases of development. (Farrer, W. and Brownbill, J. A *History of the County of Lancaster: Vol 8*. London: Victoria County History, 1914)

provide six chaplains, three within Lancaster, and one each in Caton, Gressingham and Stalmine.

Arguably, the biggest shake up in the church's history came about in 1534 when Henry VIII cut ties with the Pope and the Catholic Church, the government passed many acts with the aim of creating an independent Church of England with the monarch as its head rather than the Pope. The effect of this was to be felt in Lancaster in 1539 when Henry VIII abolished the monastic institution at the priory, promptly ending 445 years of monks living within the church, and in 1541, the priory became part of the Diocese of Chester.

Over the next hundred or so years, we do not find many mentions of the priory. We do know that by 1619 the new Jacobean Pulpit had been erected, on top of which sat a carved bible and crown; over the years, the pulpit was changed and pieces were removed and simplified. (It took until 1999 to restore and reinstate the original crown and bible.) From a surviving document, we also know that the vicar had not been undertaking his duties properly and had only preached four times that year. Other documents also state that his disregard for his duties meant that the chancel in the church was suffering from a serious state of neglect. Later in the seventeenth century, the two bells of the church were recast in Wigan in 1693.

At the beginning of the eighteenth century, there was a renewed interest in the priory and its condition. By 1704, the churchyard had become so overcrowded with bodies that it was decided to construct a charnel house that could be used to store bones from old graves that had been reopened and reused. In 1743, the steeple was raised by ten yards so that its bells could be heard better, and at the same time, the

Runic Cross in Lancaster City Museum.
(Author's photograph)

bells were also recast. Surprisingly, only ten years later in 1753, the tower had fallen into an awful state of repair and was at risk of collapse. Due to the condition, a decision was made to remove the bells to reduce the weight in the tower. Henry Sephton was asked to demolish it and reconstruct a new tower, and in 1759, the new tower was completed. The tower can be seen to this day.

In 1807, while work was being undertaken in the churchyard, a runic cross was discovered, and after a meeting with the British Archaeological Association in Lancaster, it was decided to move the cross to the British Museum in 1868. By the mid-nineteenth century, technology was advancing at a rapid rate, and investment was needed within the church. In 1847, the east window was installed, and a few years later in 1855, it was decided to stop any further burials within the churchyard. Three years later, gas lighting was installed, and for the first time it allowed the priory to be lit properly without the use of candles.

In 1870, local architects Paley and Austin undertook work on the chancel, and in the same year, they presented the church with the eagle lectern that is still used today. Twelve years later, they also constructed the vestry and added an organ chamber. Other local business people got involved with helping to restore the church. In 1885, James Williamson made a donation of £1,000 to replace the bells, and there was enough money left over to also install a new clock on the tower. The bells were rung for the first time three years later.

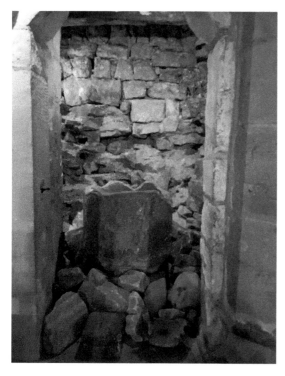

Saxon doorway. (Author's photograph)

King's Own Memorial Chapel. (Author's photograph)

As the church moved into the twentieth century, there was a period of construction but also excavation to unlock the secrets of the church and its location on Castle Hill. The King's Own Regimental Memorial Chapel was constructed in 1903. In 1912, an investigative excavation was undertaken before restoration works began. The excavation discovered a possible Roman wall beneath the chancel and also a small Saxon doorway in the west wall of the nave. The final phase of development came in the mid-twentieth century. Over the next few decades, the interior underwent some small changes, including moving the choir pews to their new location, and in 1972, the bells were once again restored and rehung. Ten years later, the organ was replaced, and in 1994, the church celebrated the 900th year since its foundation.

Quayside

One of the most important areas of Lancaster dating from the Georgian period is St George's Quay. The area developed at the height of the slave trade and was the commercial hub of Lancaster throughout the late eighteenth century. Between 1750 and 1755, the area along the riverside went from being a barren, unused space to a fully functional quayside complete with customs house, warehouses, inns and shipbuilders.

The development of the Port of Lancaster came about in 1749 with an Act of Parliament; the aim was to improve the navigation of the Lune and create the Port of Lancaster and the port commission. The Act set in place various requirements from the construction of markers near the estuary mouth, through to the building of the various warehouses and customs house.

Some of the first buildings to be constructed were the warehouses that can be seen to this day. A few years after the Act of Parliament, the most important building on the quay was constructed. The Custom House was built in 1764 and designed by Richard Gillow, a member of the Gillow family of furniture makers, and from the surviving

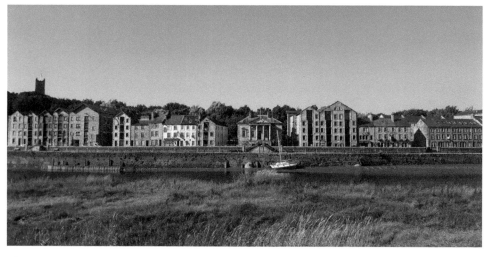

The quayside. (Author's photograph)

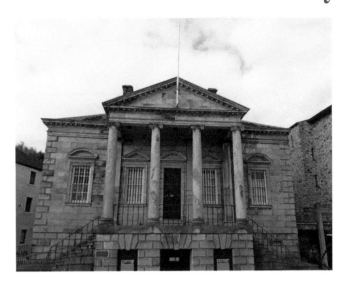

The Custom House.
(Author's photograph)

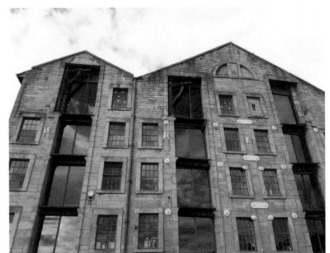

Bonded warehouses.
(Author's photograph)

records, we know that the Custom House was built in fifteen months using local stone quarried near Ellel on the outskirts of Lancaster, and the cost of the building was £784, 7s 1/2d. The Custom House was home to the customs officers who had an office on the first floor, with the upstairs of the building being used for the day-to-day transactions and payment of taxes, whereas the ground floor housed weighing scales for the goods being brought into the port.

We do not know much about the individual customs officers, but we do know that they had a lot of power in the town. It was their responsibility to ensure goods were weighed and properly taxed; they also had legal powers to seize goods and also ships if need be. One of the longest-serving officers in Lancaster was James Booth. The warehouses next to the Custom House were built later in 1797 and were used to hold the most-expensive

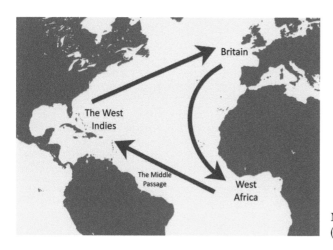

Map of the Triangular Trade.
(Author's illustration)

goods being imported. These goods had a large amount of tax placed upon them, and goods were securely locked away in what were known as bonded warehouses.

The creation of the Port of Lancaster also led to the foundation and growth of other industries within the town. The Gillows company, founded in 1730, relied heavily on imports from other ports, but upon the creation of the Port of Lancaster could import a reliable supply of exotic woods, allowing them to rapidly grow. The shipbuilding industry also developed around this time and became a large employer in the town; the most famous shipbuilder in Lancaster was Brockbank's that was founded in 1713 and expanded heavily throughout this period. Their shipyard was located in an area known as Green Ayre next to Skerton Bridge. We also know that other smaller shipbuilders existed, including Smiths and Wakefields.

The written records also give us a great insight into how trade within the town functioned, and the impact it had on Lancaster. We can carefully examine the cargoes of the various ships that were setting out on their journeys, on what became known as the triangular trade. One example we have is for the *Queen Charlotte*, a ship owned by Thomas Rawlinson. We know that the ship was heading to Demerara, South America, in June 1798. The ship had loaded a cargo of food and other materials for the long journey, including 50 boxes of candles, 20 half-barrels of red herrings, 77 cheeses and 20 kegs of split peas and barley. This is just one example, but it serves as an insight into the goods with which the ships set out. The ships would also be loaded with high-value goods used for purchasing slaves upon arrival in West Africa, and often these goods would be weaponry and related supplies.

We know from the records from this period that between 1798 and 105, huge numbers of guns, gunpowder and lead shot were being exported, with these quantities giving us an indication of the scale of the trade. Once the slaves had been bought, they would be loaded onto the ships before the second and most dangerous leg of the journey, known as the middle passage. We know that the conditions on board these ships were horrific, with slaves in cramped conditions. Disease was rife, and sanitation was very poor with reports of overflowing chamber pots a common occurrence. As well as the disease on

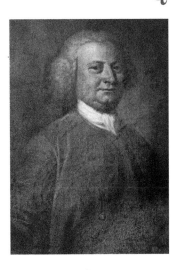

Portrait of Thomas Hinde. (Courtesy of Lancashire Museums)

board, ships also had to contend with the extreme weather and also risk of attack by pirates and other European nations vying for control of the trade routes.

If a ship successfully made the journey to the West Indies, a large amount of money could be made from the sale of slaves, and between 1761 and 1807, the average price of a slave rose from around £29 to almost £60, and from this, we can see why many people became involved in this lucrative trade. The final leg of the journey involved the now-empty ships being loaded with high-value and rare goods for the final journey back to Britain. Goods brought back included mahogany, ginger, rum, sugar and tobacco.

When we examine this period of history, we have to remember that none of this would have been possible without the merchants and captains who owned and sailed these ships. In Lancaster, during the Georgian period, we find several notable merchants who were involved in this trade to varying degrees. Most notably was Dodshon Foster who I discussed in my earlier chapter. There was also a man named Thomas Hinde (1720–1799) who was a captain and later served on as Port Commissioner; he also owned several ships, including the *Duke of Cumberland*, *Antelope* and *Thetis II*, with his business partner Miles Barber. Another notable Lancaster merchant was Thomas Rawlinson who was the senior member of a group of Quaker families, and he was the outright owner of several ships, including the *Molly*, *Ellen*, *Jane* and *Recovery*. He was also a shrewd businessman who later went into partnership with his son Abraham, and together they had an interest in coastal shipping companies in the West Indies that were used to move slaves between islands.

Unfortunately for Lancaster, by the end of the eighteenth century, there was a growing momentum behind the abolition movement, and the port suffered further in 1799 when another Act of Parliament forced all Lancaster ships to depart from the port of Liverpool. This signalled the decline of the port, and within another few years, the Act for the abolition of slavery had been passed in 1807, signalling the end of the slave trade. After this period, Lancaster's important port was no longer needed, and some of the industries connected with it, especially shipbuilding, began to close.

Although the quayside today may no longer be the hub of trade and commerce for the city, it is important that we remember that without it during the Georgian Period it is unlikely that Lancaster would have grown to be an important centre in the northwest. At its height, Lancaster was the fourth largest port for the slave trade, behind London, Bristol and Liverpool, and from the records, we know that around 29,000 slaves had been transported during this period.

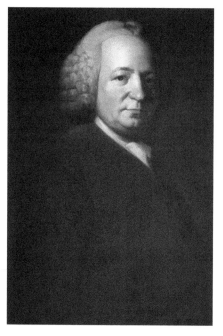

Portrait of Thomas Rawlinson. (Courtesy of Lancashire Museums)

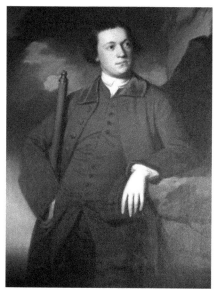

Portrait of Abraham Rawlinson. (Courtesy of Lancashire Museums)

R

Buck Ruxton
(21 March 1899–12 May 1936)

When we look at Lancaster's history, the name Buck Ruxton seems to have been forgotten, but he was the suspect in one of the most publicised cases of the 1930s. The case today is most remembered for its pioneering use of forensic science.

Ruxton was born as Buktyar Rustomji Ratanji Hakim in Bombay on 21 March 1899; he studied at the University of Bombay where he earned his medical degree. He emigrated to Edinburgh in 1927 and took a postgraduate course in medicine, and in 1930, he chose Lancaster as the city to set up his business while at the same time changing his name to the more English sounding Buck Ruxton. From the records, it has been reported that he was reputedly a hard-working GP who was popular and respected by his patients; he was also known to sometimes provide assistance free of charge if he felt that a patient could not afford to pay.

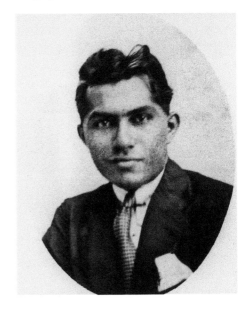

Buck Ruxton. (Courtesy of www.capitalpunishmentuk.org)

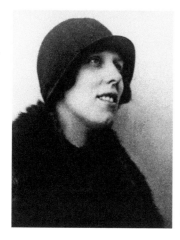

Isabella Ruxton. (Courtesy of www.capitalpunishmentuk.org)

He lived in a large house at No. 2 in Dalton Square with his wife, Isabella Kerr, a 34-year-old who we know from reports was an outgoing lady who enjoyed socialising with the elite of Lancaster. Ruxton and Kerr lived in Dalton Square with their three children, Elizabeth, William and Diane. On the surface, the family seemed to get on well, and Ruxton was known around the town for his work, however, we know that under the surface their relationship was somewhat turbulent, and he was a very jealous man and would often accuse her of having affairs. We know she reported him to the police for assaulting her, but it appears that no action was taken. Isabella also attempted suicide in 1932 and left him for a period in 1934.

It was the events over the next few months in 1936 that would not only shock the town and the country more widely but also lead to a grim end for this well-respected doctor. We know that Isabella wanted to go to Blackpool to see the illuminations and had arranged to meet her sisters there on Saturday 14 September 1935. She left Blackpool around 11.30 p.m. for the 25-mile journey to Lancaster, and it was not until the early hours of Sunday the 15th when she got home. Due to his growing jealousy and her absence, they had another argument that later led to him becoming violent and subsequently murdering her; it was also unfortunate that the murder was witnessed by the their maid, twenty-year-old Mary Rogerson, because she was also murdered in the hope of covering up what he had done. Upon later examination of the two bodies, it appeared that they were both strangled, but the precise cause of death could not be established.

Ruxton now had a serious problem, namely what to do with the bodies. He decided that to aid with the disposal of the remains, he would drag the bodies into the bathroom, drain the blood from them and then dismember and mutilate them with the aim of covering up their identities. He wrapped up the pieces in newspaper, sheets and pillowcases and then had to find somewhere to dispose of the remains. It was believed that possibly on the night of 19 September, Ruxton travelled to Scotland with the remains and threw them into a gorge near the town of Moffat in Dumfriesshire, as earlier the same day a witness saw him loading his car with parcels. What we do know

is that on 17 September while travelling back to Lancaster he injured a cyclist in Kendal at 12.45 p.m., who gave his number plate to the police. The Kendal police rang ahead to Milnthorpe, and the police put in place a road block. At around 1.00 p.m., Ruxton was stopped by the police and asked to show his license and insurance information. He claimed he was travelling back from business in Carlisle, but it has been suggested that his journey may have been to check the route up to Scotland and possibly dispose of the body parts, however we will never know what the actual trip was for.

By 29 September, both women had been missing for a couple of weeks. A tourist named Susan Johnson, who was travelling in Moffat, discovered the remains of a human arm in a local river. She went back her hotel to get her brother as she wanted to be sure of what she had found; they travelled back to the site and he discovered it was a human arm at which point the find was reported to the police. The police began to search the surrounding area and came across thirty parcels containing human body parts. The remains were examined by Professor John Glaister and Dr James Couper Brash, and they attempted to reassemble the bodies, utilising pioneering forensic techniques to try and identify the victims. One of these was done by using a picture of the person and superimposing an image of the skull over it to see if they matched. They also tried to work out the age of maggots on the remains to give an approximate date of death as well as the new technique of using fingerprints.

On 10 October, Ruxton was greeted at Lancaster railway station by Inspector Clark. Ruxton said he had been up to Edinburgh to try and find his wife and that he was unsuccessful; he also mentioned the incident with the cyclist and changed his story stating that he had not been in Carlisle, but was instead in Settle and returned via Kendal. Around the same time, Mary Rogerson's mother was worried about her daughter and asked Ruxton for answers; she was told that Mary was pregnant and had

Missing persons' report. (Courtesy of
www.lancashirescriminalpast.wordpress.com)

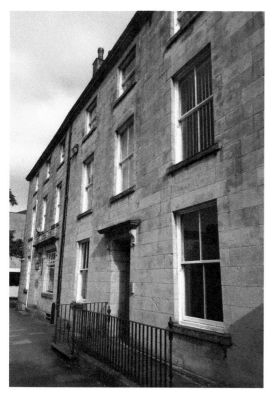

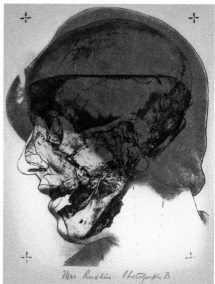

Above: Forensic photo reconstruction. (Courtesy of www.capitalpunishmentuk.org)

Left: No. 2, Dalton Square. (Author's photograph)

been sent away to have her child, however, she did not believe this story and decided instead to report her daughter as missing at Lancaster police station. Ruxton's wife Isabella was also reported as missing by members of her family. The police had to investigate and called Ruxton in for questioning, but due to his high standing in the community, they initially believed his account that Isabella had abandoned him after falling in love with someone else.

Ruxton was once again brought in for questioning on 11 October and formally charged with the murder of Mary on 13 October. On 5 November, he was also charged with the murder of his wife Isabella. Unfortunately for Dr Ruxton, his method of disposal led to his own demise. As mentioned earlier, he wrapped some of the body parts in newspaper, and some of these included a special edition of the *Sunday Graphic* from 15 September that was only sold in Morecambe and Lancaster. In addition to this, numerous bloodstains were also discovered in his house.

He was remanded until his trial, which began on 2 March 1936 and lasted for eleven days. On 13 March he was found guilty and sentenced to death for his crimes. Shortly afterwards, a petition was started with the aim of getting clemency for Dr Ruxton, however this was rejected on 27 April. The next month, on 12 May, Ruxton made his final journey to be imprisoned at HMP Manchester, also known as Strangeways. He was executed by hanging, overseen by executioner Thomas Pierrepoint, which brought Ruxton's horrific crimes to an end.

S

Sambo's Grave

Sambo's Grave is the most famous reminder of the human cost of the slave trade and its connections with Lancaster. The grave is located on unconsecrated ground near the seashore in the small village of Sunderland Point near Heysham. It is a very unusual village due to the fact that its small community gets cut-off at high tide and it can only be accessed by a small road at low tide.

At its height, Sunderland Point was a stopping point for the Port of Lancaster that served ships from the West Indies and North America. It served ships that were too large to sail up the shallow waters of the River Lune to dock at St George's Quay. Sunderland Point has a long history related to fishing and shipping, and

View of the route to Sunderland Point. (Author's photograph)

View of the second terrace. (Author's photograph)

the earliest known place for fishing was Cockersand Abbey. In 1180, the rights to the Lune fishery were given to Hugh Garth. We know from the remaining records that the monks built a fishing baulk from stone and wood that they used to catch salmon and other fish. After the dissolution of the abbey in 1539, the rector of Cockerham was legally entitled to all salmon caught at the first tide after every new moon.

Sunderland Point was developed as an out port for Lancaster by Quaker Robert Lawson at the beginning of the eighteenth century. We know that around 1700 a jetty was erected reportedly using stonework from the ruined abbey. Sunderland Point provided the perfect place for ships coming into the port as they were able to unload or wait for the high tide before sailing to St George's Quay. From the records, we are aware that Robert Lawson went bankrupt in 1728, which began a steady decline at Sunderland Point due to the lack of funds, as well as the growth of the quayside in Lancaster and later on the opening of Glasson Dock on the other side of the river in 1787. Although Sunderland Point is a very small village, it has many interesting and notable buildings and is separated into two distinct terraces. Upsteps Cottage is the most important building in this story and was originally constructed as a brewhouse for the Ship Inn; it was later used as a bathhouse and eventually became a house.

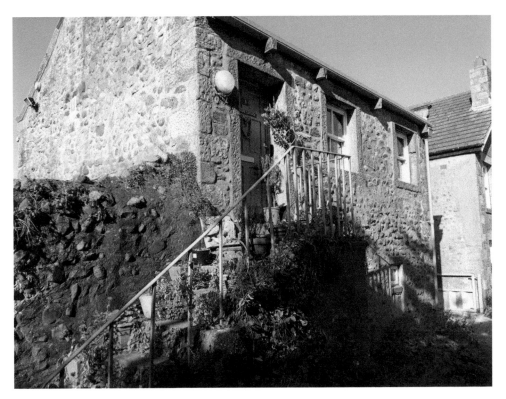

Upsteps cottage. (Author's photograph)

During the Georgian period, we know that people from all over the growing empire and along the trade routes began to come to Britain and on some occasions these were slaves, the most famous local story revolves around a man known as Sambo. Most of what we do know regarding Sambo and how he arrived in Lancaster has been passed down through local tales and stories, but there is very little written information from the time. One of the most detailed accounts comes from 1822, written almost eighty years after the event has occurred. The article states that Sambo had arrived around the year 1736 from the West Indies and was a servant to the captain of an unnamed ship:

> After she had discharged her cargo, he was placed at the inn ... with the intention of remaining there on board wages till the vessel was ready to sail; but supposing himself to be deserted by the master, without being able, probably from his ignorance of the language, to ascertain the cause, he fell into a complete state of stupefaction, even to such a degree that he secreted himself in the loft on the brewhouses and stretching himself out at full length on the bare boards refused all sustenance. He continued in this state only a few days, when death terminated the sufferings of poor Sambo. As soon as Sambo's exit was known to the sailors who happened to be there, they excavated him in a grave in a lonely dell in a rabbit warren behind the village, within twenty yards of the sea shore, whither they conveyed his remains

without either coffin or bier, being covered only with the clothes in which he died. (*Lonsdale Magazine*, 1822)

More recent suggestions are that he may have succumbed to disease contracted from Europeans, for which he had no natural immunity to. Sixty years after he was laid to rest, James Watson, a retired headmaster who worked at Lancaster Royal Grammar School, heard the story and set about raising money from visitors to the area to create a memorial for the unmarked grave. He was successful in his fundraising and wrote the inscription that to this day features on the memorial plaque.

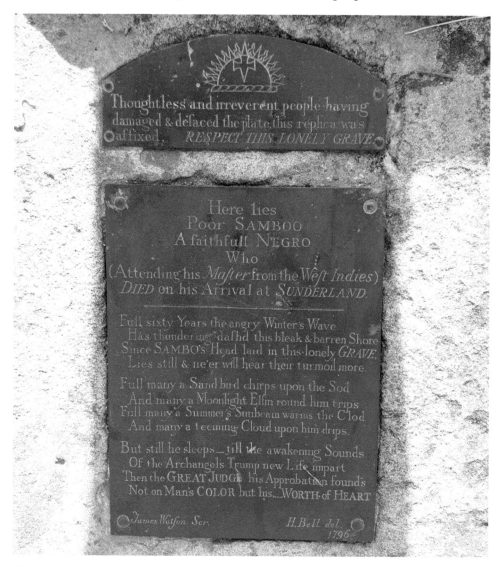

Plaque on Sambo's Grave. (Author's photograph)

T

Town Halls

When we examine the role of government in Lancaster, we find two unique and different buildings that tell us the story of Lancaster's growth and development over the past two hundred years.

The first of these buildings, located in Market Square, was formerly the original town hall and has been home to the Lancaster City Museum since 1923. The building was designed by Maj. Thomas Jarrett and was constructed between 1781 and 1783. The grand two-storey building with its Tuscan portico was built from local sandstone. The ground floor was originally open and contained an arcade, housing a market for grain and butter; these were later filled in with the current ground-floor windows.

Old Town Hall, *c.* 1938 from an old postcard. (Author's collection)

Cupola on the Old Town Hall. (Author's photograph)

Later additions were also constructed, including a cupola that was designed by architect Thomas Harrison in 1782. This interesting feature has a square base on top of which sits an octagonal section with one side containing the clock face, the final section is a round drum decorated with Ionic columns and capped by a dome. The town hall was further modified and extended in 1871 and 1886. Nevertheless, by the beginning of the twentieth century the Lancaster Corporation had outgrown its current home, and there was a need for a new town hall. As well as housing the original town hall, the building was also been home to the court, Barclays Bank until 1969 and Natwest Bank until 1977.

The new town hall can be found in Dalton Square and is still home to Lancaster City Council. Unfortunately, the corporation was unable to raise the finances for a new building; however Lord Ashton offered to pay for the construction. In 1904, a committee was formed with the aim of creating plans and coming up with a list of requirements for the new building. As part of the process, they undertook visits to various buildings throughout England in order to gather ideas. Some of the most impressive buildings they visited were designed by architect E. W. Mountfield, who had previously designed The Old Bailey and Sheffield Town Hall. It was decided that due to his impressive designs, they would employ him to design the new town hall.

Work began on constructing the building in 1906 and work was completed by 1909. Other local businesses were employed during the construction, including Waring and Gillows who were the main contractors for the stone work, joinery and supplying the furniture. The impressive stained-glass windows were created by another local

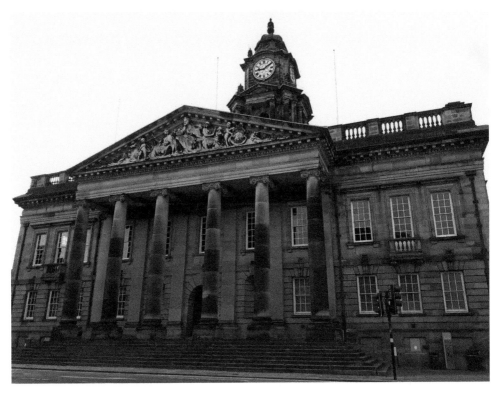

New Town Hall. (Author's photograph)

firm, Shrigley and Hunt. The new town hall housed all of the council departments in addition to the police station that was located in the basement and the magistrates court on the ground floor. The upper floors were home to the mayor's parlour, various committee and reception rooms and the Council Chamber. At the back of the building was a grand public hall known as the Ashton Hall, and next to the town hall was the new Fire Station.

Lancaster Town Hall was officially opened by Lord Ashton on 27 December 1909, and from the surviving records, we know that the final cost of the complete building, including the redevelopment of Dalton Square and the erection of the statue of Queen Victoria, was £155,000.

Unexplored Worlds

When we look a little closer at the landscape of Williamson Park, we see many interesting and extraordinary sites, however there is one feature missing from the landscape, a building which in its time was a popular attraction but nowadays seems to have been forgotten. That feature is the Greg Observatory that once stood on a prominent hilltop within the grounds of the park.

The beginnings of the observatory take us all the way back to the Georgian period. As the slave trade and the Port of Lancaster began to decline, many people began to look for new business and new opportunities, and with the expansion of the British Empire, there were many options available. The growing industry surrounding cotton was beginning to take hold, and some local businessmen who become wealthy were looking to invest their money in new businesses. Some of these men began to erect water-powered mills around Lancaster, and one of the most notable was Isaac Hodgson, who set about constructing Low Mill in Caton.

His mill began production in 1784, and by 1817, the mill had been transferred to the Greg family due to a debt that was owed, and John Greg was put in charge as manager. The business began to grow, and additional buildings were constructed in Lancaster on Moor Lane. At the same time, new advancements in technology were introduced at Low Mill, which was fitted with new steam-powered machinery.

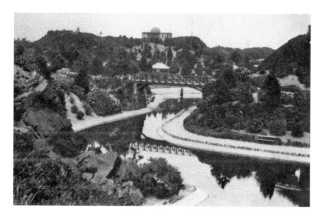

Williamson Park and the Greg Observatory from an old postcard. (Author's collection)

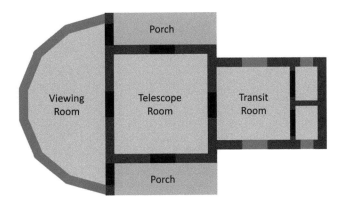

Plan of the observatory.
(Author's illustration)

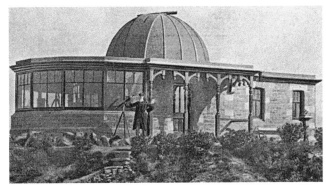

The Greg Observatory
from an old postcard.
(Author's collection)

John profited from the business and began to create a large country house at Escowbeck Cottage in Caton. It was common at the time for the wealthy to take an interest in science and learning, and John was no exception. He purchased a seven-and-a-half-inch reflecting telescope manufactured by T. Cooke & Sons and built an observatory in the grounds of Escowbeck where he installed the telescope, as well as an astronomical clock and a smaller transit telescope.

After John's death in 1882, his son Albert was unsure how to dispose of his father's possessions, as Albert had no interest in space or the observatory. His solution was to donate the equipment to the town, and he approached the Lancaster Corporation with his offer, but unfortunately, due to the high running and maintenance costs that the equipment entailed, it took almost ten years for them to come to a decision.

The observatory finally opened on 27 July 1892 with a grand celebration, attended by local dignitaries, including Dr Ralph Copeland who was born in Lancashire and became the Astronomer Royal for Scotland in 1889. The observatory was looked after by curator George Ingall, who would charge visitors one penny to see the observatory; he would explain the equipment and even provide a demonstration. Related lectures were given in the evening and were often delivered by local priest and keen astronomer Revd John Bone. It was also possible for those who were well respected to request the keys to the observatory overnight, allowing them to undertake their own observations after the park had closed to the public.

By 1905, George Ingall retired and was replaced by James Dowbiggin. Dowbiggin had been involved in taking and reporting weather readings for the area from the nearby weather station and became a recognisable face in town. The weather station instruments were located in a small enclosure close to the observatory. Every year, there was an inspection by the Meteorological Office who ensured that the equipment was well maintained and that any surrounding trees and shrubs were well trimmed, as well as checking that the records were completed correctly and kept in an organised manner. Unfortunately, in 1939, the weather station did not pass its inspection, and James Dowbiggin retired due to his age and poor health.

The problems faced by failing the inspection in addition to the retirement of James Dowbiggin meant that the Lancaster Corporation had to quickly find a new curator; someone who would be able to turn the problems around. The biggest problem was that the salary for curator was only 10s in addition to the penny admission per visitor. Knowing that they had little option, they took a radical approach and decided to work with the Lancaster Royal Grammar School, who as part of the agreement would provide the day-to-day running of the observatory while the Lancaster Corporation would ensure the building was properly maintained. With the outbreak of the Second World War, many of the teachers were taking part in the war effort, and the observatory was instead run by the more senior pupils from the school; we do know, however, that during this period, the pupils faced several issues, including mechanical problems and building-maintenance issues.

By 1944, the condition of the observatory was very bad. When the manufacturers of the telescope visited, they found that the telescope was in an awful state and quoted a large sum to repair it. However, due to the ongoing war and the weather station failing its inspection, the money could not be found, and in September, the observatory was closed and abandoned.

We know that after this point the buildings began to decay, and the surrounding trees and vegetation were allowed to takeover. The final stage of the observatory's story came about in the 1960s when the remaining equipment was taken apart and scrapped, with remaining parts of the building being demolished.

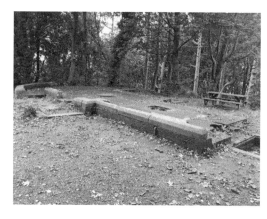

The remains of the observatory. (Author's photograph)

V

Victoria Monument

One of the large monuments in Lancaster is the Victoria Monument that sits at the heart of Dalton Square. The square sits on the original location of a Dominican Friary that was first founded around 1260. The site was sold to Sir Thomas Holcroft in 1539 after the dissolution of the monasteries for £126 10s. In 1784, John Dalton obtained permission to redevelop the site, and later in the Edwardian period, the square was once again redesigned.

Dalton Square is also home to several other notable buildings, including the new town hall, No. 2 where Dr Ruxton murdered his wife and maid, and Palatine Hall that was originally a Catholic Chapel and later became a music hall, cinema and council offices.

Photograph of the Victoria Monument, 1912.
(Author's collection)

Base Plaque showing prominent men from the Arts. (Author's photograph)

The monument was commissioned and paid for by Lord Ashton to commemorate Queen Victoria who died in 1901. It was designed by sculptor Herbert Hampton who also designed the exterior of Lord Ashton's other great monumental building, the Ashton Memorial. The Victoria Monument was originally intended to be in Williamson Park, but it was decided instead to place it in the centre of Dalton Square Lancaster facing Lancaster Town Hall with the square surrounded by new decorative sandstone walls designed by Edward Mountford.

The monument is made of Portland stone, on top of which stands Queen Victoria and four lions cast in bronze. Around the base, prominent Victorians are depicted, including local scientist Richard Owen and businessman Lord Ashton. The corner sculptures represent Truth, Wisdom, Justice and Freedom. It was unveiled in 1906, and of all the people depicted around the base, only six were still alive by its competition. To this day, the monument still sits proudly at the heart of Dalton Square surrounded by trees and plants, creating a tranquil oasis at the heart of the city.

Surprisingly the Victoria Monument is not the only one dedicated to Queen Victoria. A less well-known one can be found at the back of Lancaster Castle not far from the Hanging Corner, where you can find a small inset fountain that was constructed in 1887 to celebrate the Golden Jubilee of Queen Victoria.

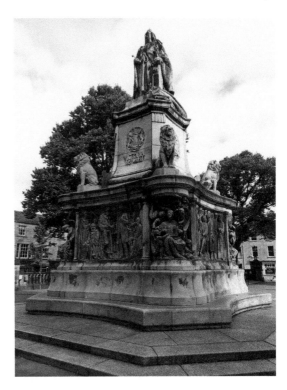

The Victoria Monument.
(Author's photograph)

Memorial Fountain.
(Author's photograph)

Witches

Most people will probably have heard of the Pendle Witch Trials of 1612 but may not necessarily know of the events around Pendle Hill that led to the trials. The trials are one of the most important to have occurred in British history and were very well recorded by clerk Thomas Potts who published his account of the trials under the title *The Wonderfvll Discoverie of Witches in the Countie of Lancaster*. He had been asked to write an account of the trials by the judges, and his book was completed by 16 November 1612; it was then revised and edited by Sir Edward Bromley before publication in 1613. We should, however, remember that although the account appears to be a record of what was said in court, it is actually more of a summary of the events. In total, twelve people were accused of murdering ten people by witchcraft and all except two stood trial in Lancaster.

The events occurred at a time when superstition was rife, and the north of England was a remote and lawless area. It was also a period in which religious persecution was a serious problem when Catholic worship had been driven underground. When Elizabeth I came to the throne in 1558, she passed an Act warning that anyone who used, practiced or exercised any form of magic, witchcraft, enchantment or sorcery where another person was killed or destroyed would be put to death.

This was furthered upon the death of Elizabeth I, when in 1603, James I, who took a keen interest in witches, came to the throne. James I had always been suspicious of witches, and during the 1590s, suspected them of plotting against him. His interest was so strong that in 1597 he published his highly regarded book *Daemonologie* that told its readers to denounce and prosecute anyone who practiced or supported the use of witchcraft. Upon ascending the throne, he passed a law that imposed the death penalty for cases where harm had been caused by magic. All these aspects led to a deep-seated fear in the population not just locally but also nationally, which in some ways can be viewed as the catalyst for the events leading up to the Pendle Witch Trials.

In 1612, every Justice of the Peace in the county of Lancashire was asked to create a list of people who refused to attend the Church of England and took communion. That was a criminal offence. Roger Nowell was the local justice in Pendle and was tasked with recording anyone in the area who deviated from the law. It was in March 1612 that he received a complaint by the family of John Law, a peddler from Halifax. Law

THE
WONDERFVLL
DISCOVERIE OF
WITCHES IN THE COVN-
TIE OF LAN-
CASTER.

With the Arraignment and Triall of
Nineteene notorious WITCHES, at the Assizes and
generall Gaole deliuerie, holden at the Castle of
LANCASTER, *vpon Munday, the se-*
uenteenth of August last,
1612.

Before Sir IAMES ALTHAM, and
Sir EDWARD BROMLEY, Knights; BARONS of his
Maiesties Court of EXCHEQVER: And Iustices
of Assize, Oyer *and* Terminor, *and generall*
Gaole deliuerie in the circuit of the
North Parts.

Together with the Arraignment and Triall of IENNET
PRESTON, *at the Assizes holden at the Castle of Yorke,*
the seuen and twentieth day of Iulie last past,
with her Execution for the murther
of Master LISTER
by Witchcraft.

Published and set forth by commandement of his Maiesties
Iustices of Assize in the North Parts.
By THOMAS POTTS *Esquier.*

LONDON,
Printed by *W. Stansby* for *Iohn Barnes,* dwelling neare
Holborne Conduit. 1613.

DÆMONOLOGIE,
IN FORME
OF A DIA-
LOGVE,

Diuided into three books:

WRITTEN BY THE HIGH
and mightie Prince, IAMES by the
grace of God King of England,
Scotland, France *and* Ireland,
Defender of the Faith, &c.

LONDON,
Printed by *Arnold Hatfield* for
Robert VValdgraue.
1603

Left: Cover of Thomas Pott's Book, 1613. (Author's collection)

Right: Cover of James I's Book, 1603. (Author's collection)

stated that on 21 March while travelling through Trawden Forest he encountered Alizon Device, the granddaughter of Demdike, a person who had been regarded as a witch for over fifty years. During this encounter, he had been asked for some pins that he was carrying; these were very expensive items as they were handmade but also they had connotations for witchcraft and could be used in various enchantments. We do not know Alizon's reason for wanting them or why Law refused, but the incident that occurred shortly after this set in motion the events that led to the trials.

Alizon claimed she wanted to purchase them and that Law would not open his pack for a small transaction. John Law was accompanied by his son Abraham, who claimed she was instead begging for them. Shortly afterwards, John started to become unsteady on his feet and fell to the ground, although he managed to get back up and go to a nearby inn. Importantly, this incident could have been seen as no more than coincidence. John Law did not make any accusations against Alizon initially, but it was sadly Alizon who was convinced that she had magical powers. A couple of days after the incident, she was taken by Abraham to see his father, and it was at this meeting that she was said to have confessed to using witchcraft and sought forgiveness.

On 30 March, Alizon, her brother James and mother Elizabeth were called before Roger Nowell to answer questions regarding the incident with John Law and their

involvement in witchcraft. At the meeting, Alizon told Law that she had given her soul to the devil and asked him to strike down John Law after he accused her of being a thief. James announced that his sister had told him that she had bewitched a local child, and their mother Elizabeth told that Demdike, the grandmother of Alizon and James, had a mark on her body, often associated with the devil sucking blood from a person.

They were also asked about Anne Whittle, also known as Chattox, and her family, with whom there had been a long-running feud. Chattox had been regarded as being a witch, and Alizon said that Chattox had been responsible for the murder of four local men using witchcraft and that her father John Device had also been killed by Chattox. She stated that her father agreed to pay Chattox with 8 pounds of oatmeal each year in return for a promise not to harm his family, and he did so every year until 1611. Just before he died, he said that his sickness had been caused by Chattox because he had not paid that year's fee.

A few days later on 2 April, Demdike was once again called up before Nowell, but this time he had also requested the presence of Chattox and her daughter Ann Redferne. At the meeting, both Chattox and Demdike gave statements that were incriminating: Chattox stated she gave her soul to 'a thing like a Christian man', and Demdike recalled that she had given her soul to the devil twenty years earlier. Importantly, Anne gave no confession at the meeting but was instead incriminated by Demdike who stated that she had seen Anne making clay figures. There was another witness seen that day, a lady named Margret Crooke, who in her statement said that her brother had fallen ill and subsequently died after a disagreement with Anne. Due to these damning confessions and statements, Nowell had no option but to send Demdike, Alizon Device, Chattox and Anne Redferne to Lancaster jail to stand trial for causing harm by witchcraft.

Their imprisonment and trial could have been the end of the matter if it had not been for another event that took place a few days later. On 10 April, which was Good Friday, Elizabeth Device arranged a meeting for friends at Malkin Tower that was the home of the Demdike family. Unfortunately, to feed the attendees, James Device stole a neighbour's sheep, and this was reported to Roger Nowell who decided that the events should be investigated further.

By 27 April, events were coming to a head. Nowell had arranged for an enquiry to be held and was this time accompanied by another magistrate, Nicholas Bannister. The aim of this enquiry was to examine what had happened at Malkin Tower and

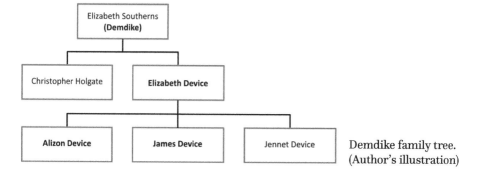

Demdike family tree. (Author's illustration)

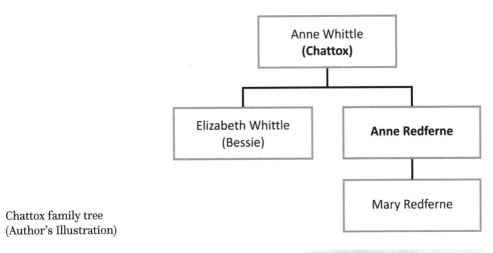

Chattox family tree
(Author's Illustration)

'Nan Redferne and Chattox'. (Ainsworth, W. H., *The Lancashire Witches*. London: George Routledge, 1854)

who attended, and the findings resulted in eight additional people being sent for trial. These people were Elizabeth Device, James Device, Alice Nutter, Katherine Hewitt, John Bulcock, Jane Bulcock, Alice Gray who were sent to Lancaster jail. Jennet Preston lived in Yorkshire, so she was instead sent for trial in York.

In the summer of 1612, the trials were just getting started. It is important to note that the Pendle Witches were tried as part of a larger group that included Jane Southworth, Jennet Brierley and Ellen Brierley, also known as the Samlesbury Witches, who were accused of murdering children and cannibalism.

The first of the witch trials took place at the York Assizes on 27 July. Jennet Preston who resided in Gisburn, then part of Yorkshire, was brought up on the charge of murdering local landowner Thomas Lister of Westby Hall. At the trial, her judges were Sir Edward Bromley and Sir James Altham, and it was to them she pleaded

not guilty of the crime. Preston was already known to Edward Bromley as she had appeared before him the year before accused of using witchcraft to murder a child for which she was found not guilty. However, on this occasion, evidence was presented that when she had been taken to see the body of Thomas Lister, his corpse began to bleed after she had touched it. It was also apparent from an earlier statement given by James Device in April that she had attended the Malkin Tower meeting and supposedly sought assistance for the murder of Thomas Lister. Due to the evidence presented, she was subsequently found guilty and two days later was executed by hanging on the Knavesmire in York.

On 18 August, the first of the Pendle Witch Trials to take place at the Lancaster Assizes began. Over the next two days, all of those currently imprisoned were tried and the evidence presented against them. The results were varied and for most of the accused, it was to be their final days. Chattox, Elizabeth Device and James Device were the first to stand trial. Chattox was brought up on the charge of the murder of Robert Nutter for which she pleaded not guilty. However, her earlier confession to Roger Nowell was then read out. In addition to this, a man called James Robinson also gave evidence against her. He has lived with the Chattox family around twenty years earlier, and he said that Robert Nutter had accused Chattox of turning his beer sour and also that among the local community, people believed she practised witchcraft. Unfortunately for Chattox, due to all the evidence presented against her, she broke down in tears and admitted she was guilty of the crimes and asked God to forgive her. She also sought help from the judges and asked them to take mercy upon Anne Redferne, her daughter. She was found guilty due to all the evidence against her.

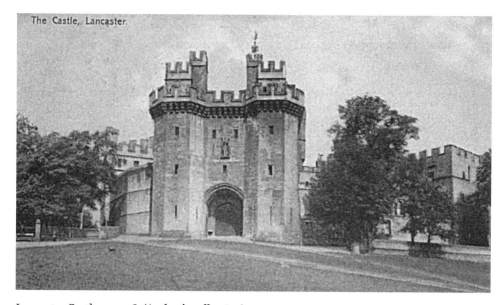

Lancaster Castle, *c.* 1926. (Author's collection)

Elizabeth Device was accused of the murders of James Robinson and John Robinson, and also with the help of Alice Nutter and Demdike, the murder of Henry Mitton. Sadly for Elizabeth, the main witness in her trial was her own daughter Jennet, who was around nine years of age at the time. The records from the trial tell us that Elizabeth began to curse and shout at her daughter when she was asked to stand and give her account, and this forced the judge to have Elizabeth removed so that Jennet could be heard. Jennet told the court that she thought her mother had been participating in witchcraft for three or four years. She also recounted that her mother had a supernatural familiar named Ball, who took the form of a brown dog. In her statement, she told that she had witnessed conversations between her mother and Ball in which she sought help for the murders. To make things even worse for Elizabeth, her son James was then called to give evidence. He told that he had seen his mother creating a clay figure of John Robinson, one of her supposed victims. Due to the evidence presented, she was found guilty. Finally that day, James Device found himself on trial for the murders of Anne Townley and John Duckworth, for which he pleaded not guilty. However, James had also previously given a confession in his statement to Nowell. In addition to this, his sister Jennet said that she had seen him conjuring up a black dog and asking it to help him kill Anne Townley. The evidence presented was enough to find him guilty.

The second and final day of the trials took place on 19 August. The first person to stand trial was Anne Redferne, and although she had been found not guilty of the murder of Robert Nutter, she found herself now accused of murdering Christopher Nutter, his father. The evidence presented against her came from a statement to Nowell by Demdike, who stated she had seen Anne making clay figures of the Nutter family, and other witnesses who were also called stated that she was a dangerous witch, but she continued to plead not guilty. Unfortunately, the evidence was deemed satisfactory enough to find her guilty. The same day, Jane Bulcock along with her son John found themselves accused of using witchcraft to murder Jennet Deane. In court, they both denied their involvement, but Jennet Device gave a statement telling the judges that they had attended the meeting at Malkin Tower. They were both found guilty of the murder.

The next person in court that day was Alice Nutter, who unusually had made no statements before or during her trial, except for protesting her innocence to the charge of murdering Henry Mitton. In court, it was alleged that with the assistance of Demdike and Elizabeth Device, they used witchcraft to cause his death after he had refused to give a penny to Demdike. The evidence supplied in court came from James Device, who said Demdike had told him about the murder and Jennet Device, who stated that Alice had attended Malkin Tower. Due to the evidence presented against her, she was found guilty. Katherine Hewitt, also known as Mould-Heeles, and Alice Gray found themselves accused of the murder of local child Anne Foulds. James Device identified them as having attended the meeting where they spoke about the murder of Anne, and Jennet Device confirmed the attendance of Katherine. Katherine

was found guilty of the murder, however Alice Grey whose trial is not recorded by Thomas Potts is listed as being found not guilty.

The final person to stand trial was Alizon Device. Unusually for her, in court, she was confronted by John Law, the man who she was accused of causing harm to and the event that led to the witch trials. Sadly for Alizon, she seemed to believe that she did have powers and thought herself to be guilty; it was reported that she fell to her knees and confessed to the crime. Due to her own outburst and the evidence presented, she was found guilty.

The trials marked a turning point in British history; they were the best recorded and arguably the most famous, and of all the accused only one person, Alice Grey, was found not guilty. It was also interesting that many of the statements given were by a young girl, who it could be argued had no real idea about what she was saying or the possible outcome of her testimony.

It is also possible that a couple of decades after the Pendle Witch Trials, Jennet Device also found herself in a similar situation. From a record dated 24 March 1634, twenty people are listed as standing trial, among the names is a woman named Jennet Device, who is accused of the murder of Isabel Nutter. The main witness during these trials was a ten-year-old boy named Edmund Robinson. Nineteen people were found guilty, but interestingly, the judges decided not to pass death sentences and instead sought the assistance of King Charles I. Edmund was cross-examined in London and was found to have made up his evidence; four of the accused were eventually pardoned, but they all remained prisoners in Lancaster Castle. Two years later, Jennet Device was still listed as being imprisoned at the castle.

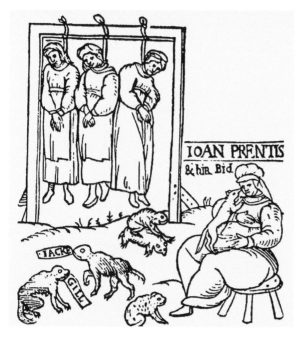

The public hanging of the three Chelmsford witches, 1598. (Author's collection)

X Marks the Spot

One of the least visited monuments in Lancaster is located in the small square outside of the Judge's Lodgings. The current cross stands on the site of a much earlier ancient cross, and these types of monument were very common around the country, especially during the medieval period. There was a resurgence in creating monuments to celebrate the monarchy during the reign of Victoria, whose silver and gold jubilees led to a huge number of monuments being created, and this was furthered after her death when many towns and cities constructed memorials of remembrance celebrating her long reign.

Covell Cross. (Author's photograph)

The current monument was designed and erected in 1903 by popular local architects Paley and Austin. It was constructed to commemorate the coronation of King Edward VII in 1902, unusually however, it is named after Thomas Covell who was the previous owner of the lodgings and also keeper of Lancaster Castle, most famously during the Pendle Witch Trials of 1612.

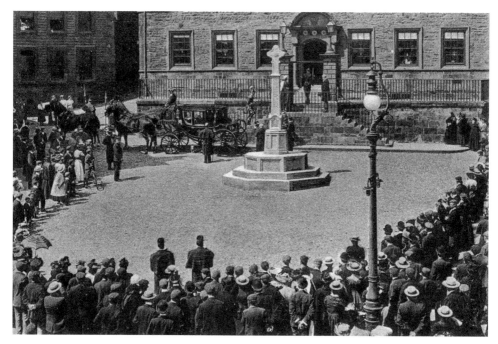

Covell Cross, *c.* 1900, from an old postcard. (Author's collection)

Y

Gideon Yates (1790–1837)

When we look back on Lancaster and its maritime past, we can still find many remnants of this period. Over the centuries, many artists, both local and national, have chosen to paint their own scenes of Lancaster life and its buildings. One of the most important periods in Lancaster's history was the Georgian period, and during this time, many notable paintings were completed that depict the lost world of Georgian Lancaster. When we take a look at these, there is one artist who captured the feel and life of the city through his work, an artist named Gideon Yates.

Unfortunately, we do not know much about his life apart from the paintings he left behind. What we do know is he worked as an insurance broker in the city, specialising in maritime insurance until 1803. A year later, due to debts he had

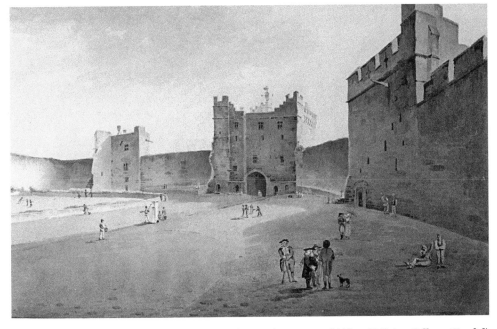

A view of Lancaster looking towards the Gatehouse. (Courtesy of Abbot Hall Art Gallery, Kendal)

accrued, he was imprisoned in Lancaster Castle. (It has been suggested that during his time locked away, he may have spent his days practising his artistic skills.) From the records, we know that by 1811, he was a full-time professional artist; he also painted several notable works of Lancaster during this period, including the quayside and Lancaster. It is through these surviving works that we can see how Lancaster evolved and changed during and after this period. By 1820, he had moved further afield and could be found in London where he created hundreds of paintings depicting the bustling city. It is these paintings that he is most well known for now, with them regularly appearing at major auction houses.

The quay at Lancaster. (Courtesy of Lancashire Museums)

Z

Zoology

When we consider the town of Lancaster and the imposing structures of Williamson Park, it reminds us of the time when parks not only served the recreational needs of the people in the town but also helped in providing an education, whether on astronomy or natural history.

Like many great parks around Britain at the time, Williamson Park was home not only to the Greg Observatory but also to a great glass building that stands at the rear of the Ashton Memorial. This building, then known as the Palm House, gives us an idea about what it was used for.

It was designed in 1904 by Sir John Belcher and was home to many exotic and unusual plants gathered from around the world. Unfortunately, in 1942, the Palm

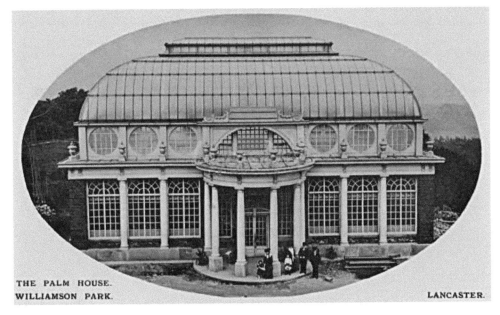

THE PALM HOUSE.
WILLIAMSON PARK. LANCASTER.

The Palm House, *c.* 1910, from an old postcard. (Author's collection)

House suffered damage from a fire, and its interior was destroyed. Over the next few decades, it was redeveloped and evolved while still maintaining it links to the past.

In the 1980s, the building became known as the Butterfly House and now houses an exotic oasis of tropical plants, trees and flowers as well as serving as a home to many species of butterfly, and ponds full of koi carp. As well as the Butterfly House, you will also find the mini beast house, home to many creatures, including lizards, snakes, spiders and frogs. There is also an outside area, home to an aviary and more recently meerkatsp

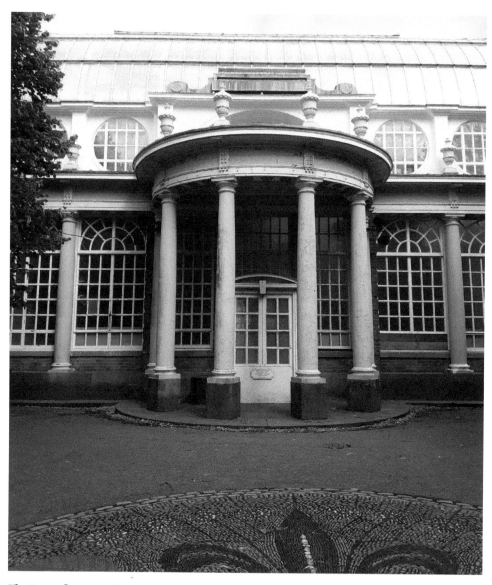

The Butterfly House. (Author's photograph)